Mexican Art

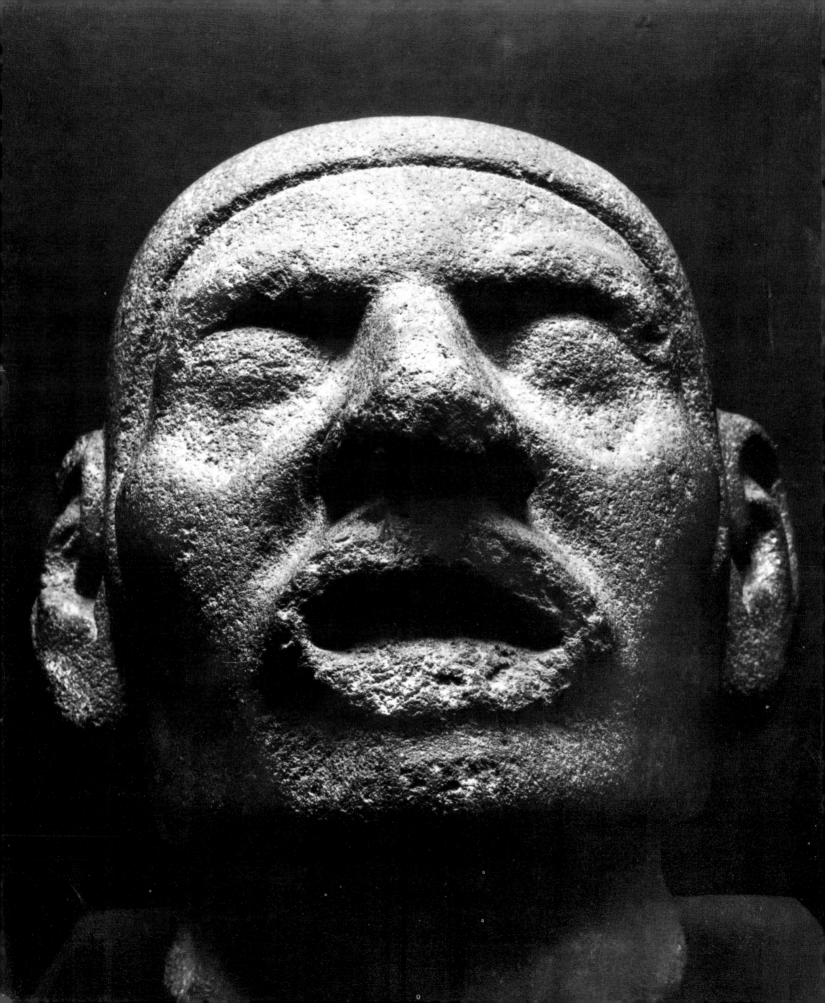

Justino Fernández

Mexican Art

Photographs by Constantino Reyes-Valerio

The Colour Library of Art

Hamlyn

London · New York · Sydney · Toronto

Acknowledgments

The publishers gratefully acknowledge the copyright owner's permission to quote on pages 27-32 from the following works: *Aztec Thought and Culture. A Study of the Ancient Náhuatl Mind* by Miguel Leon-Portilla. Translated from the Spanish by Jack Emory Davis. University of Oklahoma Press, Norman, 1963 (reproduced by permission of the author); *Cartas de Relación by Hernán Cortés Prólogo by Manuel Alcalá*. Editorial Porrua, México, S. A. 1960. *Literary Remains of Albrecht Dürer* by William Martin Conway. Cambridge University Press, 1889; *Maya and Mexican Art* by Thomas Athol Joyce, 'The Studio' Ltd., London, 1927; *The Dialogues of Cervantes de Salazar*, facsimile with a translation by Minnie Lee Barrett Shepard. University of Texas Press, Austin, 1953; *Mexican Painting and Painters. A brief sketch of the Spanish School of Painting in Mexico* by Robert H. Lamborn. Allan Lane and Scott, Philadelphia, 1891; *Obras Completas* by José Martí, Vol. V. Editorial Lex, Havana, Cuba, 1942; *José María Velasco 1840-1912* Catalogue of the Exhibition organised by the Philadelphia Museum of Art and the Brooklyn Museum, 1944-45; *Las obras de José Guadalupe Posada, Grabador Mexicano*, with an introduction by Diego Rivera. Mexican Folkways, Mexico City, 1930; *Textos de Orozco*. Instituto de Investigaciónes Estéticas, Universidad Nacional Autónoma de Mexico, 1955; *Creative Art*, New York City.

Autoridades Eclesiásticas de la Catedral de Mexico, Mexico City (Plate 36); Instituto Nacional de Antropología e Historia, Mexico City (Plates 1, 2, 3, 4, 6, 7, 8, 16, 17, 24, 25, 26, 27; Figures 1, 8); Instituto Ruiz Cabañas, Guadalajara, Jalisco state (Plates 50, 51); Museo de Arte Moderno, Instituto Nacional de Bellas Artes, Mexico City (Plates 44, 45, 52, 53; Figures 4, 6, 7); Museo de Artes e Industrias Populares, Mexico City (Plates 54, 55, 56, 57, 58, 59); Museo Regional de Oaxaca (Plates 18, 19); Museo de La Venta, Tabasco state (Plate 9); Pinacoteca Virreinal, Instituto Nacional de Bellas Artes (Plates 32, 33); Secretaría de Agricultura, Mexico City (Plates 46, 47); Secretaría del Patrimonio Nacional, Mexico City (Plates 48, 49); Señora Margarita Orozco and Family, Mexico City (Plates 50, 51).

All the colour transparencies were made specially for this book by Señor Constantino Reyes Valerio, Mexico City, D.F.

Frontispiece: 'Head of a Dead Man'. Basalt. 12 × 11 in. (31 × 28 cm.). Aztec culture. 15th century. Museo Nacional de Antropología, Mexico City

NOTE ON PRONUNCIATION

Náhuatl or Mexican has been the language of large parts of Central America from Toltec times to the present day. The Roman alphabet was introduced by the missionaries immediately after the Spanish conquest, and the sound values of the spelling are therefore the same as they were in early sixteenth-century Spanish. The main sounds for the English reader to note are the following:

Mexican		English	Mexican		English
x	=	sh	Quetzalcóatl	=	*Ketsal-Kwattle*
hu	=	w	Náhuatl	=	*Ná-Wattle*
que	=	kay	Xochimilco	=	*Shochimilco*
coa	=	kwa	Huehue	=	*Whaywhay*
j	=	h			
h	=	wh			

First Published 1965
Revised Edition 1967
Paperback Edition 1970
Published by The Hamlyn Publishing Group Limited
London · New York · Sydney · Toronto
Hamlyn House · The Centre · Feltham · Middlesex
© Copyright Paul Hamlyn Ltd 1965

ISBN 0 600 03748 7

Printed in Italy by Officine Grafiche Arnoldo Mondadori, Verona

Contents

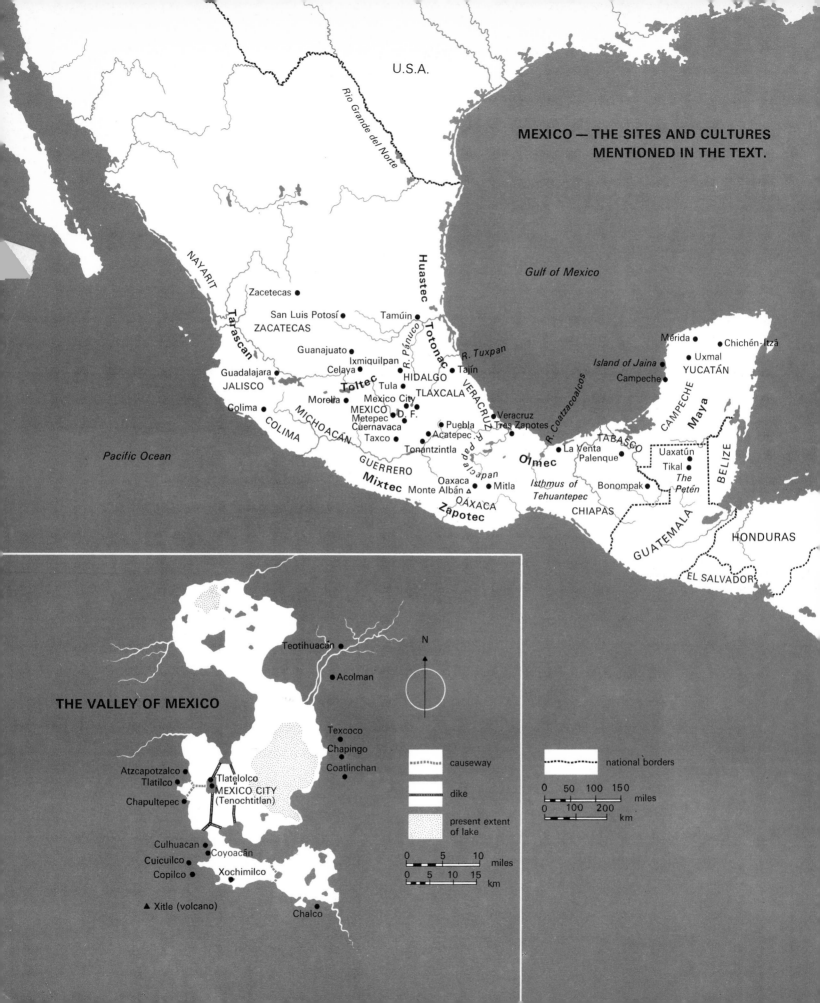

MEXICO — THE SITES AND CULTURES MENTIONED IN THE TEXT.

U.S.A.

Rio Grande del Norte

Gulf of Mexico

NAYARIT

Tarascan

Zacetecas

San Luis Potosí

ZACATECAS

Tamúin

Huastec

R. Pánuco

Totonac

Mérida

Chichén-Itzá

Island of Jaina

Uxmal

YUCATÁN

Guanajuato

Ixmiquilpan

Celaya

R. Tuxpan

Campeche

Guadalajara

JALISCO

Toltec

HIDALGO

Tajín

Tula

TLAXCALA

VERACRUZ

CAMPECHE

Maya

Colima

Morelia

Mexico City

MEXICO

D. F.

R. Coatzacoalcos

COLIMA

MICHOACÁN

Metepec

Cuernavaca

Puebla

Veracruz

Tres Zapotes

TABASCO

Uaxatún

BELIZE

Taxco

Acatepec

La Venta

Palenque

Tikal

Pacific Ocean

GUERRERO

Tonantzintla

R. Papaloapan

Olmec

The Petén

Mixtec

Oaxaca

Mitla

Isthmus of Tehuantepec

Bonompak

Monte Albán ▲

OAXACA

Zapotec

CHIAPAS

GUATEMALA

HONDURAS

EL SALVADOR

THE VALLEY OF MEXICO

Teotihuacan

Acolman

N

Texcoco

Chapingo

Coatlinchan

Atzcapotzalco

Tlatilco

Tlatelolco

MEXICO CITY
(Tenochtitlan)

Chapultepec

Culhuacan

Coyoacán

Cuicuilco

Copilco

Xochimilco

▲ Xitle (volcano)

Chalco

┄┄┄ causeway	┄┄┄ national borders
─║─ dike	
░░░ present extent of lake	

0 50 100 150 miles

0 100 200 km

0 5 10 miles

0 5 10 15 km

Introduction

Mexico, of all the modern nations in the American continent, has behind her the richest continuous artistic heritage, reaching far back over a period of twenty centuries. Diverse and contrasting though the sources and phases of Mexican art may be, it has at all times a recognisable personality, and it shows this today in an especially marked degree. In Mexico we can see the truly spectacular fusion of an old and highly developed native civilisation with Renaissance and modern European culture, bearing fruit in a major contribution to world art.

A survey of the long progress of Mexican art shows how many different art forms have flourished in the country, and how each period in Mexico's history has left its legacy of works of art of high originality and expressive power. This history falls into three quite distinct phases.

First, the ancient Indian or pre-Columbian period which goes back to the first appearance of man in America, apparently in the Pleistocene age, and reached its apogee in the early years of the sixteenth century A.D. During the final 1500 years of this period a variety of cultures flourished, each with a distinctive character, sometimes alongside each other, and each of them must therefore be considered on its own.

The Spanish conquest between 1518 and 1521 destroyed the ancient and indigenous civilisation. In its place, the conquerors established the contemporary civilisation of western Europe, in the particular form it had taken in Spain. This Spanish colonial period endured in Mexico for three centuries and created a new nation — New Spain. Known also as the 'viceregal' or 'Hispano-Mexican' period, it came to an end early in the nineteenth century. With the War of Independence, ascendancy in the country passed from the class of the Spanish-born to that of the 'Creole' or Mexican-born landed aristocracy.

Several decades of turbulence followed the achievement of independence, the struggle for which lasted from 1810 to 1821, ending with a short-lived First Empire under the military leader Agustín de Iturbide. In the course of the ensuing civil wars between Centralists and Federalists for the establishment of a republic, General Antonio López de Santa Ana rose to power and dominated the country with dire results for a time, during which Mexico lost a great deal of its territory. Texas revolted in 1835, and by the end of the war with the United States in 1847 the territory of modern Colorado, New Mexico, Utah, Arizona, Nevada and California was ceded by Mexico. Ten years later, Benito Juárez, a Zapotec Indian by blood, inspired the promulgation of the Reform laws. Juárez was president when the conservatives, falling in with the ambitions of Napoleon III of France, set up a second empire with Maximilian of Habsburg on the throne. The emperor's reign was short (1864-1867) and came to a tragic end with the victory of Juárez after France had been obliged to withdraw her troops. The republic had survived and the struggle to make a modern nation of Mexico was continued. The long dictatorship of General Porfirio Díaz from 1877 to 1911 (during all but the four years of which he held the presidency) was superficially prosperous but reactionary in its nature. It ended soon after the outbreak of the Mexican revolution in 1910, a new Constitution in the spirit of Juárez being proclaimed in 1917. The revolution, although protracted at the political level, marked the beginning of a profound renewal in the economic, social and cultural life of Mexico. As the Mexican nation began to discover its real identity, a new and excitingly modern civilisation came into being.

The cultural legacy of ancient or pre-Columbian Mexico is now recognised as one of the great treasures of the whole of mankind. The works of the ancient native world that have come down to us are remarkable for their decorative and plastic originality and for their emotive power, and now constitute one of the major fields of study for the historians of art and civilisation. Archaeologists have already brought innumerable works of art to light and their zeal holds the promise of still more discoveries. Scholars are working on the interpretation of the inscribed and written texts, and when these can be fully translated they will throw a great light on the knowledge and beliefs of the peoples of this vanished world.

Although the origins of the pre-Columbian civilisations lie several millennia B.C., the works that we know, and which interest us as art, belong in fact to the Christian era. But as these cultures developed separately, in isolation from others in America and cut off from contacts with both Europe and the Far East, each followed a characteristic and distinct

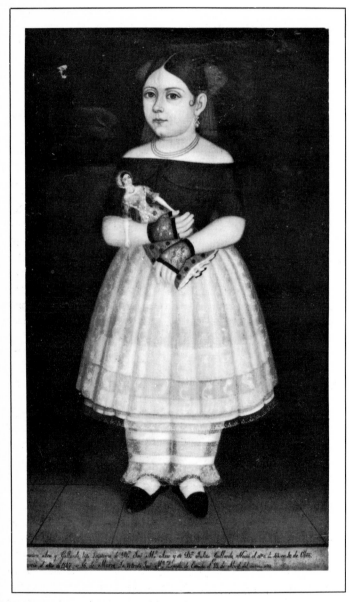

2 José María Estrada (fl. 1830-1860), 'Portrait of a Girl.' Oil on canvas.
35½ × 23½ in. (90 × 60 cm.). 1847. Private collection, Mexico City.

course of its own. Nevertheless, in their attitudes towards life and the universe, and in the way in which they attempted to resolve the eternal questions of life and death which haunt the human mind, these cultures show affinities with those of other peoples, and demonstrate the high degree of development attained by the civilisations of ancient Mexico.

Although the problem of the origin of man on the American continent has given rise to some varied theories since the sixteenth century, the only one which can be regarded as having scientific value today is that of migration from northern Asia across the Bering Straits through Alaska towards the south, perhaps some ten thousand years B.C. Although man did not actually originate in America, the civilisations that eventually arose there were fully indigenous to the continent. The first inhabitants who arrived from Asia were hunters, mostly nomadic. A long period elapsed before the immigrants in the central part of the American continent which is now called Mexico could, with a climatic change at the end of the Pleistocene age, evolve a settled way of life and start their advance towards a higher level of culture. As to the formal resemblances which may be detected between American and Far Eastern cultures, these are coincidental. But the theory of immigration from Australia should not be lightly dismissed.

The 'archaic horizon' is the term given by anthropologists and archaeologists to the far-off origins of these native cultures which existed in the millennia before the time of Christ. The oldest architectural remains that have been found are a circular temple platform at Cuicuilco, on the southern outskirts of Mexico City. It was preserved by being submerged in lava from the volcano Xitle. The structure is a low truncated cone on a circular base with four stepped tiers and stairways on the east and west sides. The temple itself was probably situated on the flat top. This structure is similar in conception to the pyramids of later periods, and the associated human burials discovered at Copilco beneath the lava are proof of an ancient but already well-developed culture, with evidence of a cult of the dead, religion, architecture and other art forms.

Likewise, the *Tlatilco* culture, known from the pottery sculpture which is found around Atzcapotzalco, north-west of Mexico City, seems to date from the archaic period in the

Valley of Mexico (see the Time Chart on pages 22-23). Numerous very elegant terracotta figurines of naked women are typical of this culture, their broad hips and bulging thighs set off by narrow waists. The male figurines are less exaggerated in their physical features.

There is still no absolutely reliable dating for the earlier pre-Columbian periods, but the age and sequence of the various civilisations have been reasonably well established from the archaeological evidence and by the method of radio-carbon testing (measuring the level of radioactivity of the decaying residue of natural carbon-14 in organic remains).

However, most of the important manifestations of ancient Mexican art fall within the period from 200 B.C. to the Spanish conquest in the 1620s. This broad category includes many cultures, different in form but sharing certain common features: the invention of calendars and time scales, the precise observation of the movements of the planets, religion with accompanying rituals and sophisticated decorative symbolism are basic common features of the ancient, native civilisation of Mexico, all of which indicate the extent of its intellectual and spiritual range and demonstrate a genius for artistic expression.

The cultures that flourished down the tropical coast of the Gulf of Mexico from the south of the river Pánuco to the states of Tabasco and Campeche in the south-east during the first five centuries of the Christian era seem to be among the oldest known to us. The *Huastecs* in the north of Veracruz state were related to both the Mayas and the Totonacs. They were notable sculptors and some of their human figures carved in stone wear highly original headdresses, although the bodies are shown naked. An exceptionally fine example of their sculpture is that of a youth known as the Huastec adolescent (plate 7). The *Totonac* culture existed farther south along the coast from the Tuxpan to the Coatzacoalcos rivers. Fine Totonac sculpture has also been found (plate 4), and if the Totonacs were indeed the builders of the pyramids at Tajín (plate 5), then they must also have been great architects. A third culture known as *Olmec* existed in the region of the river Papaloapan and on the coast of Tabasco state, producing sculpture of striking design and artistry. It is possible that the culture of the Olmecs preceded that of the Mayas, since it seems to have extended south and east of the high-

lands. Its vestiges include a number of colossal stone heads found at La Venta and Tres Zapotes, in Tabasco state (plate 9), and stone altars with frontal reliefs of human figures carrying babies in their arms, the whole scene emerging from the jaws of a serpent.

The expressive gifts of the *Olmecs* can be seen at their best in the numerous votive 'axes' (plate 3) and 'palms' which have come down to us, as well as in the 'yokes' which were beautifully carved U-shaped stone objects used in connection with the ball-game rituals (see note on plate 14). The 'smiling heads' in terracotta are another peculiar achievement of ancient Mexican art. The Olmecs were outstandingly clever sculptors, and their carved jade (plate 8) is of great beauty.

The culture of western Mexico known, not very exactly, as the *Tarascan* culture, was the creation of a tribe who settled mainly in the region of the present states of Michoacan and Jalisco, as well as in Colima and Nayarit. The ceramic sculpture from this part of Mexico is particularly attractive for its animation, varied human interest and the simplicity of its forms (plates 1 and 2). The works known to us belong to a period between the eleventh and twelfth centuries, but the artistic output of pottery had begun there before the birth of Christ and continued until the fifteenth century.

One of the greatest cultures was that of the *Mayas*, and its development is complex. It was located partly in the south of Mexico in what is now the state of Chiapas, but it extended as far north as the Yucatán peninsula; to the republics of Guatemala, Honduras and El Salvador in the south-west; and to Oaxaca state in the east. There are traces of Maya culture in the isthmus of Tehuantepec and to the north, along the coast of the Gulf of Mexico. It began with a pre-Classic period from about 1500 B.C. to A.D. 300, followed by the Classic period from 300 to 900. Its great and final period was from 900 to 1200 in Yucatán, where it came under Toltec influence, followed by the period of decadence which lasted until 1500. The original Maya cultural centres are in the sites of Uaxactún and Tikal in the Peten, or 'lake-and-islands' region, of northern Guatemala. The famous religious city of Palenque lies to the west in Chiapas state.

Standing in the centre of Palenque is the 'Palace', and to the north and south other structures such as the Temples

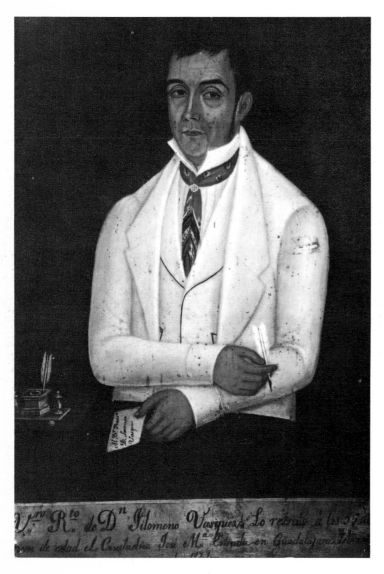

3 José María Estrada, 'Portrait of a Man.' Oil on canvas. 23½ × 17¾ in. (60×45 cm.). 1884. Private collection, Mexico City.

of the Cross and of the Sun. To the south-east of the 'Palace' is the pyramid with the Temple of the Inscriptions (plate 10) which has attracted particular interest since the discovery in 1950 of a tomb below the temple at ground level. In the centre of a crypt with relief carvings on the walls, a monolithic sarcophagus was found, covered by a great stone slab also carved with reliefs, and containing the remains of a richly apparelled personage in a jade mask (plate 11).

Maya architecture of the Classic period is of great artistic importance, as are also the contemporary reliefs, stelae, and other sculptures. The buildings of Bonampak (Chiapas state), where the now famous mural paintings were discovered, date from the same epoch, to which the calendar manuscript called the *Dresden Codex* also belongs.

The scene of the second great age of Maya culture was in the north, in Yucatán state, but this post-Classic period, from the ninth to the twelfth centuries A.D., is better called a *Maya-Toltec* culture, since migrations from the central highlands, in particular of the Toltecs, introduced new ideas and art forms. When combined with those of the Mayas, they gave rise to such remarkable monuments as the architectural complexes at Chichén Itzá (plates 13 and 14), Uxmal (plate 15) and elsewhere. A recent theory, however, based on scientific and archaeological data, suggests that Uxmal may be much earlier, belonging to the Puuc style of the Classic Maya period.

West of the Mayas, in what is now the state of Oaxaca on the southern Pacific coast of Mexico, the *Zapotec* and *Mixtec* cultures developed at successive periods during the Christian era. Monte Albán is a great temple centre with pyramids and other religious and civil buildings. A discovery of recent years is a treasure trove of much later fifteenth-century objects in gold and semi-precious materials which had been hidden in tomb 7 (plates 18 and 19). Monte Albán on its acropolis site on the summit of a mountain is a splendid architectural achievement. Mitla, another religious centre, 30 miles east of Monte Albán, belongs to the end of Zapotec culture (see the Time Chart on pages 22-23). Of particular interest are the remarkable geometric and fretted designs on the walls of its buildings (plate 20). The Mixtecans were excellent potters (plates 16 and 17) and manuscript illuminators who

influenced the art of the peoples of the central plateau, including the Aztecs.

Even more remarkable and impressive are the religious cities built in the valleys of the central highlands. Teotihuacan is unrivalled for the perfection of its layout and the severe monumentality of its pyramids of the Sun (plate 21) and of the Moon and of other buildings, such as the 'Citadel' and the much earlier Pyramid of Quetzalcóatl (plate 22). Vestiges of mural paintings have been found in buildings in near-by Tetitla, Tepantitla (plate 23), Quetzalpapálotl and others. Much archaeological and reconstruction work has been done and is still in progress on these sites, and the results have been so important that our knowledge of Teotihuacan is being added to all the time. The site flourished as a cult centre at various periods from probably the fourth to the ninth centuries A.D., when the drying-up of the surrounding countryside caused its abandonment.

A very influential culture was that of the energetic *Toltecs* which came into being in the ninth century and flourished until the twelfth century. Their capital city was Tula, in what is now the state of Hidalgo, north-west of Teotihuacan and Mexico City, on the edge of the northern desert plains. The Toltecs were a creative and aggressive people who evolved a civilisation with a series of architectural and sculptural styles which even influenced the Mayas of Yucatán (plates 14 and 15). To their successors, they seemed to have been a race of cunning artists and were regarded as the source of artistic skill. Their example left a profound impression on all the peoples of Náhuatl culture in the Mexican highlands, including the Aztecs.

The Náhuatl language was spoken by a number of tribes originating in the north, probably on the Gulf coast. The Toltecs of Tula belonged to the Náhua family and so did other groups which founded cities in the Valley of Mexico from the twelfth century onwards, such as Coatlinchan, Texcoco, Coyoacán, Atzcapotzalco, Culhuacan, Chalco and Xochimilco. The *Aztecs* or Mexica were the last group to enter this region from the north, in the middle of the thirteenth century. They were originally a small tribe of nomadic hunts-

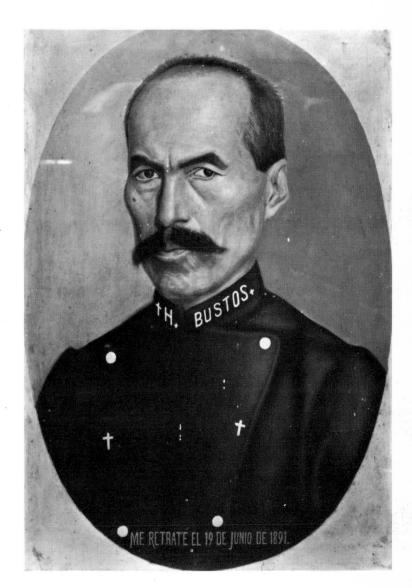

4 Hermenegildo Bustos (1832 - 1907), 'Self Portrait.' Oil on canvas. 14½ × 10½ in. (36 × 26 cm.). 1891. Museo de Arte Moderno, Mexico City.

men in the northern desert. Speaking Náhuatl, they settled, after many difficulties, on an island in the lake and founded Tenochtitlan in 1325. Within a hundred years they had assimilated the existing culture and had not only conquered the surrounding lands but had rapidly extended their empire from the Gulf coast to the Pacific and as far south as Guatemala. Their culture was highly developed at the time of the Spanish conquest. Not only was the capital, Tenochtitlan-México, the greatest city in the whole of pre-Columbian America, but it was also the only one that had fully urban characteristics. The city was reached by a great causeway and was planned on a grid of streets and a network of canals and divided into *calpullis* or districts. Its religious centre was a great quadrangle containing the pyramids of the temples of Tláloc, the rain god, and of the Aztecs' titular deity Huitzilopochtli, the war god, a precinct unique of its kind. Tenochtitlan was destroyed after its surrender to the Spanish conquistadores on August 13th, 1521. And it was here in the same place Cortés founded the new city of Mexico as the capital of New Spain.

The Aztecs had profited from the knowledge and achievements of the cultures which had preceded them in the Valley of Mexico, but their own contribution was unique. Their sculpture is unrivalled for originality and grandeur, and is recognised as among the finest in the history of world art (plates 24, 25, 26 and 27).

To describe all the other minor cultures that we know existed in ancient Mexico since prehistoric times, and to enumerate every variety of art form which was produced, would only be confusing. The purpose of the foregoing survey has been to pick out clearly the components of the civilisation which the Spanish conquerors found flourishing in the second decade of the sixteenth century. The impressive art of the Aztec empire which they overthrew was the outcome of a long development, and the Aztecs themselves owed it, like most of their achievements, to their predecessors in ancient Mexico.

With the Spanish Conquest, western art took root in the country and at once began to grow. It is hard to over-estimate the importance in this of the religious orders whose missionary friars did so much to christianise the natives and supply them with a spiritual foundation for their new way of life.

The first Franciscans arrived in 1523, followed by the Dominicans in 1526, and lastly the Augustinians (Austin Friars) in 1533. The mendicants built their great houses in the cities and regions of the country and organised it in provinces of their orders. With vast courtyards, churches, cloisters, gardens and aqueducts, these buildings were the first centres of the new culture and it was here that the Spanish language and the arts were taught and that the natives received spiritual guidance and, frequently, material help. The Franciscan friaries of Mexico City and Tlatelolco with their colleges were educational and cultural centres destined to play an important part in the history of Mexico. Sixteenth-century religious houses were generally magnificent edifices; those of the Franciscans tended to be austere, the Augustinian friars rich and spacious (plates 28 and 29), those of the Dominicans defensive and massive. These buildings are remarkable for the cheerful eclecticism with which they combined elements of Romanesque and Gothic with Renaissance style. For the better instruction of the Indians in the Catholic faith, they were decorated with fresco paintings (plate 30). Before the building of the great churches, the architects had first erected *capillas abiertas* (open chapels) or porches as an original solution to the problem of how to hold religious ceremonies in the open before a great number of worshippers. In some cases the original open chapel came to form the apse of the later church. Great gilded altars with reredos were built inside and decorated with paintings and sculpture (plate 31).

The Jesuits arrived in Nueva España (New Spain) in 1572, from which date onwards the secular clergy became increasingly important. The clergy built colleges, hospitals, convents for nuns, parish churches, chapels and cathedrals. Civil as well as religious architecture flourished. Palaces, both for the Crown and for magnates, aqueducts, fountains and private houses gave a noble air to towns and villages. Cities on the Gulf coast such as Veracruz and Campeche were enclosed by walls, but these were an exception, since the greater number of the cities that were founded or rebuilt were open, with straight streets and large squares.

Few sixteenth-century palaces have survived, but those of Cortés at Cuernavaca and of Montejo at Mérida are

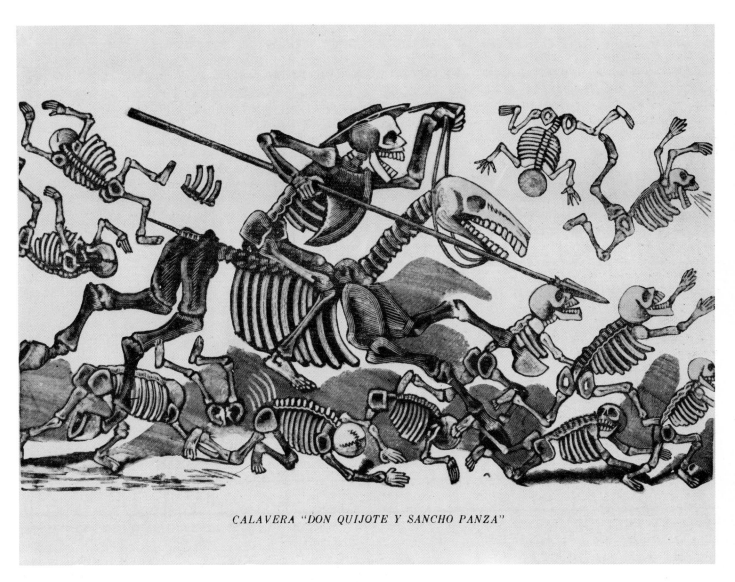

CALAVERA "DON QUIJOTE Y SANCHO PANZA"

5 José Guadalupe Posada (1852 - 1913), 'Don Quixote and Sancho Panza.' Woodcut.

magnificent examples. Some cathedrals, like Guadalajara, were still built with Gothic interiors, but the cathedrals of Mexico City and Puebla, completed in the seventeenth and eighteenth centuries, were begun in the full classical Spanish style. The most notable cathedral in the north of Mexico is at Zacatecas (plate 35).

The seventeenth century was the great age of highly decorated church interiors, sanctuaries and chapels being gorgeously ornamented with gilded altarpieces and polychromed stucco (plate 34). The Baroque exteriors were often given large façades encrusted with a wealth of beautiful reliefs (plate 35). This century was the best period of colonial painting, the Creole (or native-born, Spanish-blood) artists showing considerable talents in styles which, though derivative of Spain, are distinctly Mexican (plates 32 and 33).

Baroque art reached its climax in the eighteenth century in a complexity of forms and fantastic elaboration taken to such extremes that it becomes necessary to invent a special art term, 'Ultra-Baroque', to describe the new style. Ultra-Baroque combined several contemporary trends, including 'Churrigueresque', named after the Spanish architect José de Churriguera (1665-1725), and Rococo. The first work representing the Churrigueresque style with its superabundance of decoration and its play of colours is the magnificent Altar of the Kings (plate 36) in Mexico Cathedral.

Baroque, in this final and most exuberant phase, is the language of innumerable works of art throughout the country. The combination of Spanish-Latin temperament with native outlook made Mexico the home of Baroque at its most expressive. Parish churches were built in every part of Mexico with soaring towers, imposing façades, and gilded interiors glittering like jewel-cases. Many regions developed a local variant of the style. One of the finest and most sumptuous churches is Santa Prisca in Taxco (Guerrero state). In the region of Puebla a popular Ultra-Baroque style produced such singular works as the interior of the church of Santa Maria Tonantzintla (plates 39 and 40). Not far away, the church of San Francisco Acatepec has a façade entirely covered with polychrome tiles in the Puebla style (plates 37 and 38). This form of decoration recalls, at first sight, the Moorish tradition of the *mudéjar* style in Spain. The technique was introduced into Mexico by the Spaniards,

who established potteries in Puebla, but the style is in fact highly original, as the detail shows. Another fine building is the Sanctuary of the Virgin at Ocotlán in Tlaxcala state (plate 41) with its high twin towers flanking a richly carved façade in the form of a monumental shrine and painted entirely in white to contrast with the red brick of the lower half of the towers on either side.

The effect of wealth was shown in the opulence of eighteenth-century building in Mexico. Many good examples have survived. Humboldt called Mexico City 'the city of palaces' and, indeed, some are still standing, like the mansions of the Conde del Jaral (Palacio Iturbide) and of the Conde de Santiago de Calimaya (now the Museum of Mexico City, plate 43), to show that the great explorer had not been mistaken. A peculiar local style in civil architecture came into being at Puebla, the best example being the so-called 'Sugar-candy House' (Casa de Alfeñique, plate 42), which really does resemble a gigantic cake with icing on top.

The end of the eighteenth century brought in the new international taste in art, the Neo-classical style. By order of King Charles III of Spain, the Royal Academy of San Carlos de la Nueva España was founded in 1785. An influential artist from Valencia, Manuel Tolsa (1757-1816), completed the cathedral of Mexico, and the cupola he built for it is proof of a refined taste. He also built the Mineria Palace (the school of mines), one of the most imposing classical buildings in the Americas, and made the much admired equestrian bronze statue of King Charles IV which now stands in the Paseo Reforma in Mexico City. The Creole artist Francisco Eduardo Tresguerras (1759-1833) built large churches at Celaya (Guanajuato state), El Carmen and other works elsewhere in the region. The Mexican development of Ultra-Baroque came to an end with the triumph of Neo-classicism, but a number of fine works in the new style were produced in the final years of the colonial period.

The Neo-classical style continued to prevail in all the arts in Mexico throughout the years of the War of Independence, of the First Empire and beyond. It represented a conscious statement in favour of modernity and a reaction against the style of the colonial past. Mexico was struggling to become a modern nation and adoption of the Neo-classical movement with its French revolutionary association gave a

sense of participating in cosmopolitan progress. The Academy of Fine Arts which had been established by order of King Charles III of Spain almost came to an end on the death of the main artists who belonged to it and with the achievement of independence.

The arts languished for a while, and were left, on the whole, to foreign artists who were working in the country. D'Alvimar painted a beautiful view of the Plaza Mayor in Mexico City. Linati set up a lithographic press and in 1828 published, in Brussels, a book of considerable social, political, and local interest illustrated with his own magnificent colour lithographs, entitled *Trajes Civiles, Militares y Religiosos de México* (*Mexican civil, military and religious costumes*). Johann Moritz Rugendas (1802-1858) of Augsburg painted a series depicting various aspects of Mexican life. The Comte de Waldeck (1766-1876), with his passion for archaeology, drew the ruins of Palenque in the 1830s, and later published prints of some of these drawings in his *Voyage pittoresque* (Paris, 1838). Daniel Thomas Egerton painted the excellent landscapes and views which were reproduced in his volume of *Views in Mexico* (1840). Artists like these were mainly interested in exhibiting to the Old World the curiosities and riches of Mexico's ancient monuments, customs and everyday life. Meanwhile the Academy continued to lead a lingering existence until finally closing its doors. The book that gives the best idea of the cultural situation in the country is *Life in Mexico*, the letters of Madame Calderón de la Barca, published in 1843.

General Santa Ana's government drew up plans for the modernisation of the country, in which the Academy was given a part to play. By presidential decree, it was provided with the means for its revival, and it opened its doors again in 1847. European masters were invited on contract to come to teach in Mexico. For painting there was Pelegrin Clavé y Roque (1811-1880), from Spain, who introduced the Neo-classical style, and painted a series of interesting portraits. He was followed by the Italian landscapist, Eugenio Landesio (1810-1879). Another Spaniard, Manuel Vilar (1812-1860) was contracted for the sculpture school. Juan Cordero (1824-1884), a Mexican painter who had studied in Rome, returned to Mexico and was soon in competition with Clavé. Cordero was also a fine portraitist, and painted the large historical

6 Julio Ruelas (1870 - 1907), 'The Moorish Queen (La reina mora).' Etching. 7^{1}/$_{16}$ × 5^{1}/$_{8}$ in. (18 × 13 cm.). 1906. Museo de Arte Moderno, Mexico City.

and religious scenes beloved of the period, reviving the art of monumental painting and himself decorating the cupolas of the churches of Santa Teresa and San Fernando in Mexico City in his own markedly individual style. His mural, no longer existing, in the National Preparatory School (Escuela Nacional Preparatoria) was the first Mexican fresco with a modern philosophical theme — Science, Industry and Commerce driving out Ignorance and Envy. With a lesser degree of success, Clavé and his pupils also decorated the cupola of the church of La Profesa in Mexico City; these paintings disappeared many years ago. Santiago Rebull painted the portraits of the Emperor Maximilian and his consort Carlotta which are now in the palace of Miramar, and lived on almost to the end of the Academy's existence.

The art of the Academy derived from the Neo-classical school, but, while relying on the theories of Ingres, it was contemporary with the Romantic movement in Europe and was therefore susceptible to its influence — particularly that of the German Romantics. Delacroix, however, had no followers in Mexico. The Academics produced quite adequate work of a sentimental nature, but the most novel and interesting of them was a pupil of Landesio, the great Mexican landscape painter José María Velasco (1840-1912). His great panoramas of the Valley of Mexico (plate 44) are an original and poetic vision of the American landscape. He won recognition in his own country, in the United States and in Europe, and his work merits a place beside that of Corot, Théodore Rousseau, and of other landscape painters of the Romantic era. The Italian Javier Cavallari, who was born at Palermo in 1811 and came to Mexico in 1856, taught architecture, and Lorenzo de la Hidalga (1810-1872) built in the classical style a National Theatre which no longer exists.

So-called Popular painting flourished at the same time, independent of the academic school. It is greatly esteemed today for its attractive freedom and spontaneity, especially work by José María Estrada (figures 2 and 3), who was born in Guadalajara (Jalisco state) and flourished from 1830 to 1860, and Hermenegildo Bustos (1832-1907: figure 4), a native of Guanajuato (Guanajuato state). Of the two, Bustos was the more naturalistic painter. Throughout the century, lithographs of a high standard were produced, some satirical in the manner of Daumier, others being genre scenes and topographical views. The work of graphic artists like las Castro, Hernández, Escalante and Villasana is as good as any being produced at that period anywhere in the world.

The last quarter of the nineteenth century saw an increase in patriotic romanticism. The monument to the last Aztec emperor, the heroic Cuauhtémoc, was erected in Mexico City in 1887, surmounted by an imposing bronze statue by Miguel Noreña. Leandro Izaguirre (1867-1941), painted the execution of Cuauhtémoc, the last Aztec emperor and Felix Parra (1845-1919) a picture of Fray Bartholomé de las Casas, the Indians' champion.

At the end of the nineteenth century a forceful and revolutionary artist made his appearance in Mexico — José Guadalupe Posada (1852-1913). His engravings in the popular style, such as the one reproduced on page 14, provide a vivid panorama of Mexican daily life, its pleasures and tribulations, before the beginning of the revolution. The freedom with which he expressed his ideas and feelings, which were highly critical of society, places him among the first Expressionists. His influence on the direction of twentieth-century art in Mexico is immense. As a political commentator and in his spirited use of the human skeleton as a satirical character he is profoundly Mexican in feeling (see plates 17 and 55).

Julio Ruelas (1870-1907: figures 6 and 7) was a draughtsman, engraver and painter with a very unusual style of macabre expressionism. His anguished and fantastic vision of the human condition was rooted in the realities of eroticism and death.

The example of the Impressionist and Post-impressionist movements in Europe gave new life to landscape painting. The highly personal version of Impressionism of Joaquín Clausell (1866-1935) and the 'syntheticism' of Dr Atl (Gerardo Murillo, 1875-1964) represent the necessary steps towards the liberation of landscape painting from the shackles of the academic tradition.

What the new term 'syntheticism' (*sintetismo*) meant is seen best in the work of Saturnino Herrán (1887-1918). In his creative years he dispensed with the classical ideal of beauty in depicting the history of Mexico. Herrán found his subject matter in the reality of Mexican life and gave expression to the Creole spirit, that mingling of native and Spanish traditions, and painted well-observed Mexican types of differ-

7 Julio Ruelas, 'Art Criticism (Self Portrait).' Etching. 6¾ × 5⅛ in.
(16 × 13 cm.). 1906. Museo de Arte Moderno, Mexico City.

ent social classes with real sympathy (plate 45). He is a forerunner of the art which was to come immediately after him — modern Mexican mural painting. He had himself intended to use this medium in a great frieze entitled *Our Gods* (*Nuestros Dioses*) which was contemplated for the new National Theatre (now the Palace of Fine Arts), but never executed. In his style, which owes much to Gauguin, via the Spanish painter Zuloaga, and in his folkloric themes, Herrán initiated one of the currents which make up the modern movement of Mexican painting.

The movement of renewal in every aspect of Mexican life and culture that accompanied the Revolution in 1910 found outstanding expression in mural painting. This movement was not only political and social but amounted, in fact, to a renaissance of national consciousness which was to express itself in the most varied forms. It anticipated the many other revolutionary movements of the century and coincided with the upheaval in European thought, art and literature that took place in the years before, during and after the First World War.

In 1922 the mural painting movement was launched by a group of Mexican artists inspired by new social ideals, and in the space of a few decades it came to be the most important manifestation of modern Mexican art. Humanist and therefore universal in spirit, it is inspired by history and by everyday life. Its aesthetic values lie in an originality and grandeur of conception whereby great painting on public buildings was to be accessible to all. Mexican mural painting demands appreciation for the rich complexity of its emotional and thematic content and not merely for its unusual subjects. A distinguishing characteristic of the great mural painters is their critical approach to history, which varies according to the temperament of each one of them.

An artist of the stature of Diego Rivera (1886-1957) is rare in the history of any country. A highly gifted draughtsman and colourist, his drawing is classical in spirit while his use of colour is romantic. His first important contributions to twentieth-century art are cubist, and in themselves display a very original aspect of that movement. After studying in Mexico and Europe, he returned to his own country to paint the first important mural, in the Anfiteatro Bolívar in 1922. This work has a philosophical theme: *Primera Energía*, the primal energy out of which everything is born and to which everything finally returns, including Man with all his powers and potentialities and Woman likewise. His frescoes for the Salón de Actos (Auditorium) of the National Agricultural School at Chapingo (1927) are probably his masterpiece. On the old walls and the vaults of this Baroque building he painted his sequences of *Biological evolution* and *Social evolution*, the two meeting in a synthesis in which mankind is seen to have succeeded in harnessing the forces of nature (plate 46). In this revolutionary work, Mexican reality appears as an instance of the social philosophy which so strongly motivated Rivera's painting. His female nudes in this series are among the most impressive in modern art, an outstanding one being the monumental *Mother Earth asleep* (*la tierra dormida*, plate 47).

The series of frescoes for the presidential palace (Palacio Nacional) in which Rivera interprets Mexican history (the staircase up to 1935, and the corridors from 1943 onwards) constitute a stupendous epic vision, coloured by the artist's own ideas and convictions. He endowed the native past of his country with a new ideal of beauty, and in a very large composition he imaginatively reconstructed the market-place of the ancient capital city of Tenochtitlan-México (plate 48), a beautifully composed work in striking colours.

For expressiveness, technique and inspiration, the work of José Clemente Orozco (1883-1949) is without parallel. An original and powerful artist, his tragic view of existence is profoundly moving. He began painting as an Expressionist and his work of around 1913 anticipates much mid-century art. His first main period begins with his frescoes for the National Preparatory School of San Ildefonso in 1922-27 (plate 49) and ends with the remarkable *Prometheus* in 1930 in Pomona College, California. He did not visit Europe until 1932. In the ensuing years he revised his style and executed his great frescoes in the City of Guadalajara. Those in the amphitheatre of the University of Guadalajara and in the vaulting of the Government Palace are magnificent, but his finest achievement is in his frescoes made in 1939 for the auditorium (the former chapel) of the Instituto Cabañas. Here he painted *La Conquista* depicting the atrocities and contradictions of the modern world (plate 50). But these are seen not as the whole

of man's being, for this is synthesised in the painting for the cupola, where all the varied aspects of the human condition are resumed in the allegorical figure of the *Man of flames* (plate 51), a breathtaking existential symbol.

Orozco's monumental paintings have no parallel in the history of modern art, and he is a unique artist, only Goya's frescoes in the church of San Antonio de la Florida in Madrid offering a precedent.

David Alfaro Siqueiros (born in 1896) is an equally original, powerful and dramatic artist. Interested in new techniques and materials, he has used pyroxylin (a compound, related to gun-cotton, with remarkable drying properties) as a medium, and in various ways has been a stimulus for other mural artists. His first paintings for the National Preparatory School are already powerful works, but he revised his style in later murals. His paintings in Hospital No. 1 of the Seguro Social (Social Welfare Centre) deserve careful study, as do those in the Mexican Revolution room of the Museum of History at Chapultepec.

He has not neglected easel painting and his self-portraits (plate 52) have a moving quality which comes from the authority of his technique and the force of his personality. His contribution to contemporary art has been a rich one. There can be little doubt that Diego Rivera, José Orozco and David Siqueiros are masters of the twentieth century, ranking with the great masters of the past.

Mexico has been fortunate in having produced outstanding artists at a time of historic social and political change. Chief among them at the present day is Rufino Tamayo (born in 1899). Entirely different in style from the three others just mentioned, he is a painter of unrivalled subtlety as may be seen in his delicate geometrical compositions as much as in his deceptively simple themes. Above all, he is a great colourist. Throughout his career he has remained faithful to his own personal vision and has not allowed himself to be influenced by current fashions among the mural painters. He has produced many easel paintings of great excellence; while mural paintings like *Homage to the race* (*Homenaje a la raza*, plate 53), a large allegory for the Bank of the Southwest at Houston, Texas, called *América*, those in the Palace of Fine Arts in Mexico City and one depicting the *Combat of Night (Tiger) and Day (Plumed Serpent)* painted in 1964 in the new Museum of Anthropology at Chapultepec, Mexico City, are highly original works. They place him as a leading figure in the movement of modern art — a painter who achieves universality while remaining essentially Mexican.

This essentially Mexican quality, what one may call the national sensibility, can be discerned in popular handicrafts and folk art. Here, the variety and the richness of colour and form (plates 54 and 55) give to the objects a feeling which comes from a genuineness and spontaneity of expression in combination with skill and inherited knowledge. Folk art has flourished throughout Mexican history, either in the form of objects for practical use (plates 56, 57 and 58) or for purely decorative or for ritual purposes (plate 59). All of them show the marks of a strong artistic sense in their makers. These small and often fragile creations are in a way the artistic sap running through the nation, nourishing its more conscious artists, and taking a rightful place beside its acknowledged works of art.

Table of Chronological Correspondences

AD	100	200	300	400	500	600	700	800	900		1000	1100

OLMEC

TOLTEC

HUASTEC TOTONAC

AZTEC

TEOTIHUACAN

MIXTEC ZAPOTEC

CLASSIC MAYA

POST CLASSIC MAYA

WESTERN (Tarascan)

ANCIENT INDIAN CIVILISATIONS

THE ARTS IN MEXICO

AD	100	200	300	400	500	600	700	800	900		1000	1100

EARLY CHRISTIAN

ROMANESQUE

BYZANTINE

GOTHIC

THE WESTERN WORLD

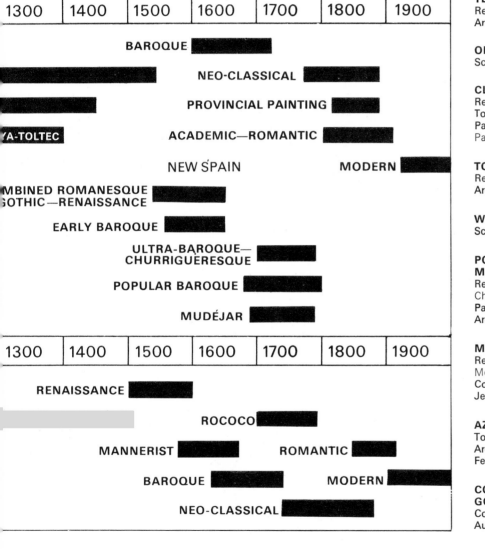

1300	1400	1500	1600	1700	1800	1900

BAROQUE ▮

NEO-CLASSICAL ▮

PROVINCIAL PAINTING ▮

...A-TOLTEC ACADEMIC—ROMANTIC ▮

NEW SPAIN MODERN ▮

...MBINED ROMANESQUE
...OTHIC—RENAISSANCE ▮

EARLY BAROQUE ▮

ULTRA-BAROQUE—
CHURRIGUERESQUE ▮

POPULAR BAROQUE ▮

MUDÉJAR ▮

1300	1400	1500	1600	1700	1800	1900

RENAISSANCE ▮

ROCOCO ▮

MANNERIST ▮ ROMANTIC ▮

BAROQUE ▮ MODERN ▮

NEO-CLASSICAL ▮

TEOTIHUACAN
Religious centre : Teotihuacan
Architecture · Sculpture · Painting

OLMEC HUASTEC TOTONAC
Sculpture · Pyramids : Tajín

CLASSIC MAYA
Religious centres
Town planning · Sculpture
Painting · Codices
Palenque, Bonompak

TOLTEC
Religious centre : Tula
Architecture · Sculpture

WESTERN (Tarascan)
Sculpture in clay

**POST CLASSIC MAYA
MAYA-TOLTEC**
Religious centres :
Chichén Itzá, Uxmal
Palaces : Kabá, Labná
Architecture · Sculpture

MIXTEC ZAPOTEC
Religious centres :
Monte Albán, Mitla
Codices · Architecture · Sculpture
Jewellery

AZTEC
Town planning : Tenochtitlan
Architecture · Sculpture · Painting
Featherwork · Codices · Jewellery

**COMBINED ROMANESQUE—
GOTHIC—RENAISSANCE**
Convents : Franciscan
Augustinian, Dominican

EARLY BAROQUE
Cathedrals · Parish churches
Civil architecture

POPULAR BAROQUE
Tonantzintla

BAROQUE
Cathedrals : Mexico, Puebla
Guadalajara, Morelia, Zacatecas

**ULTRA-BAROQUE—
CHURRIGUERESQUE**
Mansions
Façades : El Sagrario, Mexico City
Gilded interiors : Altar of the
Kings of Mexico Cathedral, Taxco
Parish churches

MUDÉJAR
Acatepec

NEO-CLASSICAL
Minería Palace
Equestrian statue of Charles IV,
Mexico City
El Carmen, Celaya

ACADEMIC—ROMANTIC
Landscape painting : *Velasco*

PROVINCIAL PAINTING
Estrada, Bustos

MODERN
Popular illustrations : *Posada*
Nationalism in painting : *Herrán*
Mural painting from 1922 :
*Orozco, Rivera, Siqueiros,
Tamayo*
Architecture : University City

Documents on Mexican art

THE NAHUATL LEGEND OF THE SUNS

The Náhuatl people conceived of there being five different periods of time in relation to the universe. A supreme deity, Ometéotl, who was both masculine and feminine, was the creator of the gods and the origin of all things. Ometéotl was the true support of all universals. The first four gods were his sons, warriors striving to identify themselves with their father the Sun, each one of them destined to predominate in turn in his own period of the universe. One of them ruled each period, or Sun, and was also identified with one of the elements — earth, wind, fire and water — and likewise with the four cardinal directions. There had thus been four previous Suns, and the fifth is the one we are still living in. A number of post-conquest chronicles record the *Legend of the Suns*, but the fullest account seems to be that dating from 1558:

1 Here is the oral account of what is known of how the earth was founded long ago. *2* One by one, here are its various foundations (ages). *3* How it began, how the first Sun had its beginning 2513 years ago — thus it is known today, the 22nd of May, 1558.

4 This Sun, 4-Tiger, lasted 676 years. *5* Those who lived in this first Sun were eaten by ocelots. It was the time of the Sun 4-Tiger. *6* And what they used to eat was our nourishment, and they lived 676 years. *7* And they were eaten in the year 13. *8* Thus they perished and all ended. At this time the Sun was destroyed. *9* It was in the year 1-Reed. They began to be devoured on a day (called) 4-Tiger. And so with this everything ended and all of them perished.

10 This Sun is known as 4-Wind. *11* Those who lived under this second Sun were carried away by the wind. It was under the Sun 4-Wind that they all disappeared. *12* They were carried away by the wind. They became monkeys. *13* Their homes, their trees — everything was taken away by the wind. *14* And this Sun itself was also swept away by the wind. *15* And what they used to eat was our nourishment. *16* (The date was) 12-Serpent. They lived (under this Sun) 364 years. *17* Thus they perished. In a single day they were carried off by the wind. They perished on a day 4-Wind.

18 The year (of this Sun) was 1-Flint. *19* This Sun, 4-Rain, was the third. *20* Those who lived under this third Sun, 4-Rain, also perished. It rained fire upon them. They became turkeys. *21* This Sun was consumed by fire. All their homes burned. *22* They lived under this Sun 312 years. *23* They perished when it rained fire for a whole day. *24* And what they used to eat was our nourishment. *25* (The date

was) 7-Flint. The year was 1-Flint and the day 4-Rain. *26* They who perished were those who had become turkeys. *27* The offspring of turkeys are now called *pipil-pipil*.

28 This Sun is called 4-Water; for 52 years the water lasted. *29* And those who lived under this fourth Sun, they existed in the time of the Sun 4-Water. *30* It lasted 676 years. *31* Thus they perished; they were swallowed by the waters and they became fish. *32* The heavens collapsed upon them and in a single day they perished. *33* And what they used to eat was our nourishment. *34* (The date was) 4-Flower. The year was 1-House and the day 4-Water. *35* They perished, all the mountains perished. *36* The water lasted 52 years and with this ended their years.

37 This Sun, called 4-Movement, this is our Sun, the one in which we now live. *38* And here is its sign, how the Sun fell into the fire, into the divine hearth, there at Teotihuacan. *39* It was also the Sun of our Lord Quetzalcóatl in Tula. *40* The fifth sun, its sign 4-Movement. *41* Is called the Sun of Movement because it moves and follows its path. *42* And as the elders continue to say, under this sun there will be earthquakes and hunger, and then our end shall come.

From *Aztec Thought and Culture. A Study of the Ancient Náhuatl Mind* by Miguel Léon-Portilla. University of Oklahoma Press, 1963.

OPINIONS ON ANCIENT INDIAN ART

The conqueror Hernán Cortés, in his second Relation on the Conquest of Mexico addressed to Charles V on October 22nd, 1520, referred to the Indian treasure he had taken:

[Objects] which were so utterly marvellous that, for their novelty and strangeness, are without price, nor is it to be believed that any of the known princes in the world should possess any of such quality. And let not what I am telling Your Highness seem fabulous, for it is the truth that the said Muteczuma had the most lifelike copies made of every created thing of which he had knowledge, whether on land or at sea, in gold and silver as well as in precious stones and feathers, so perfectly done that these seemed to be the originals themselves.

Albrecht Dürer (1471-1528) visited Brussels from August 26th to September 3rd, 1520, and there he saw displayed in the town hall some of the treasure from the newly discovered and conquered land. He commented, rather breathlessly, in his journal:

I saw the things which have been brought to the King from the new land of gold (Mexico), a sun all of gold a whole fathom broad,

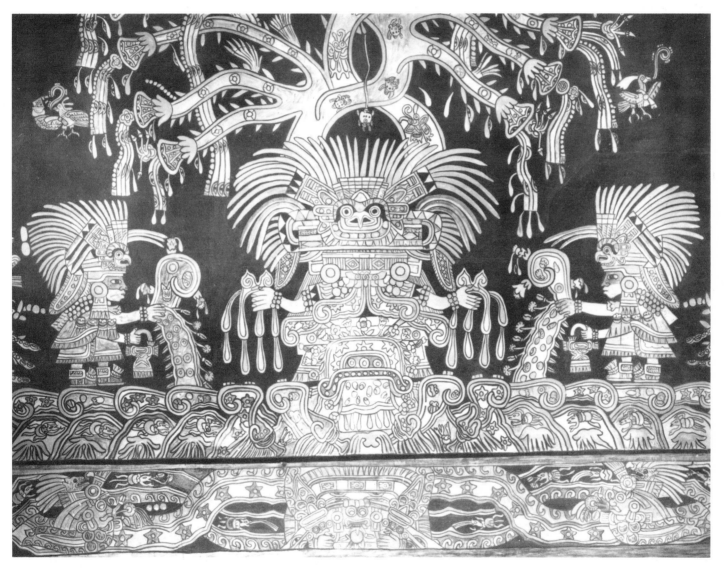

8 Tlaloc, the rain god, in his heaven. Water flows from his hands and water creatures play at his feet. Reconstructed mural from Tepantitla. Teotihuacan culture. 1st to 6th centuries A.D. Instituto Nacional de Antropología e Historia, Mexico City.

and a moon all of silver of the same size, also two rooms full of the armour of the people there, and all manner of wondrous weapons of theirs, harness and darts, very strange clothing, beds, and all kinds of wonderful objects of human use, much better worth seeing than prodigies. These things were all so precious that they are valued at 100,000 florins. All the days of my life I have seen nothing that rejoiced my heart so much as these things, for I saw amongst them wonderful works of art, and I marvelled at the subtle *Ingenia* of men in foreign lands. Indeed I cannot express all that I thought there.

The German explorer and naturalist Alexander von Humboldt (1769-1859) spent the year 1803 in Mexico, and on his return to Europe published his *Political Essay on the Kingdom of New Spain*. Humboldt had visited the San Carlos Academy and added these reflections:

The remains of Mexican sculpture, those colossal statues of basaltes and porphyry, which are covered with Aztec hieroglyphics, and bear some relation to the Egyptian and Hindoo style, ought to be collected together in the edifice of the academy, or rather in one of the courts which belongs to it. It would be curious to see these monuments of the first cultivation of our species, the works of a semi-barbarous people inhabiting the Mexican Andes, placed beside the beautiful forms produced under the sky of Greece and Italy.
Versuch über den politischen Zustand des Königreichs Neu-Spanien, Book II, chapter VII, page 168. Published by Cotta in Tübingen in 1809-13. French and English editions appeared in 1811.

The archaeologist Thomas Athol Joyce defined the qualities of Maya as opposed to Aztec art in his book *Maya and Mexican Art*, 1927:

It was the command of line which enabled the Maya artist on occasions to express motion, though his technique was fundamentally monumental and static ... For the most part of it is characterised by a calm and almost superhuman serenity ... often approaching the terrific ... Maya sculpture is supreme in delicacy of outline and modelling; Aztec stone work is supreme in vigorous simplicity and in a certain quality of fierceness.

OPINIONS ON THE ART OF NEW SPAIN

The first professor of rhetoric at the university established in Mexico City in 1553 was Francisco Cervantes de Salazar. In 1554 he published his Latin *Dialogues* as exercises for the use of his students. In the following conversations from *The Interior of the City of Mexico*, which uses the device of showing

round a visitor (Alfaro), the author gives a vivid description of the best part of the city as it was scarcely thirty years after its reconstruction:

ZUAZO. Clearly it is time, Zamora that we conduct our friend, Alfaro, a second Ulysses, through the City of Mexico, as he earnestly desires, that he may view the magnitude of so great a city ... What street shall we start on?
ZAMORA. Tacuba Street, one of the more famous, which will lead us straight to the plaza.
ALFARO. How the view of this street exhilarates the mind and refreshes the eyes! How long it is, how wide! How straight, how level it is! And the whole street is paved with stones to prevent its becoming muddy and filthy in the rainy season. Through its middle water flows in an open canal, which adds to its beauty and its usefulness to the people, and gives them more pleasure.
ZAMORA. What do you think of the houses on both sides of the street, built so regularly and evenly and none varies a finger's breadth from another?
ALFARO. They are all magnificent and elaborate, and appropriate to the wealthiest and noblest citizens. Each is so well constructed that one would call it a fortress, not a house.
ZUAZO. Because of the large, hostile population, they had to be built like this at first, since it was impossible to surround the city by walls and defend it by towers ... Now here is the plaza. Look carefully, please, and note if you have ever seen another equal to it in size and grandeur.
ALFARO. Indeed, none that I remember; and I don't think that its equal can be found in either hemisphere. Good heavens! How level it is and how spacious! How gay! How greatly embellished by the superb and magnificent buildings that surround it on all sides! What order! What beauty! What a situation and location! Truly, if those colonnades that we are now facing were removed, it could hold an entire army ... The City of Mexico is everywhere; that is, it has no suburbs and is beautiful and distinguished on all sides ... What an elegant plaza follows next, and how admirably it enhances the houses about it, in themselves no less handsome. And the view from here along the paved street into the country is most charming ... There is nothing in the City of Mexico undeserving of great praise.

In 1891 Robert H. Lamborn, the American collector of Spanish colonial painting, wrote:

I am persuaded that students of history will in due season recognize the fact that the repositories of our neighbouring republic contain ample material for a treatise which would be honoured in the annals of art, and form a memorable chapter in the record of human culture ... the great historians of art apparently have maintained a 'conspiracy of silence' regarding artists of New Spain.
Mexican Painting and Painters. A brief sketch of the Spanish School of Painting in Mexico. New York, Limited edition, 1891.

OPINIONS ON NINETEENTH
AND TWENTIETH CENTURY ART

Cuba's national hero José Martí was living in Mexico as a young man in 1875 and published a series of brilliant articles on the exhibition at the Academia that year. His admiration for Velasco's *Valley of Mexico* is expressed in the following lines:

Let us stop in front of it — let us stop and admire this outstanding landscape, lovely as nature itself, splendid as our sky, vigorous like our trees, limpid as the calm waters of our majestic lake Texcoco . . . this man has placed himself upon a high eminence of genius . . . the Valley of Mexico has a magnificent beauty and Velasco's landscape has the same grandeur.

A large exhibition of Velasco's paintings was held in Mexico City in 1942, and in 1944-5 it was shown at the Philadelphia Museum of Art and the Brooklyn Museum. In the catalogue, the curator and critic Henry Clifford wrote:

José María Velasco deserves to be known internationally as one of the great landscape painters of modern times. Certainly he is the finest landscapist the Western Hemisphere has yet produced . . . he has been re-discovered this time to take his rightful place in the history of American art.

In his introduction to a study of the work of Posada, the popular engraver (see pages 14 and 18), Diego Rivera wrote in 1930:

Two very well defined tendencies in the field of art have always existed in Mexico, one having positive values and the other negative qualities . . . the positive has been the work of the people . . . Of these artists the greatest is, without doubt, the engraver of genius José Guadalupe Posada. Posada, as great as Goya or Callot, an inexhaustible and rich creator, produced as copiously as a welling spring.

When UNESCO held its meeting in Mexico in 1948, José Clemente Orozco wrote in retrospect of the modern mural painting movement·

The Mexican painter turned his sight and his thought towards his own potentialities finding in his own traditional forms his true personality, and so enriching anew the culture to which he belonged, by virtue of the strength of his own sensibility . . . It is well known that he has put all his passion into the paintings executed on the walls of large public buildings, into mural painting — perpetually on view to the people, painting that can be neither bought nor sold, which speaks to all who pass by . . . in it you can discover almost exactly what Mexico is thinking, what Mexico loves and hates; what worries her, what obsesses her, what disturbs her; what she fears and what she hopes . . . The upshot, in fact, is a complete examination of conscience . . . It must be recognised that the reason why one finds the expression of so many different attitudes in Mexican painting is the absolute freedom in which the artist has worked.

'Mexico y su pintura', reprinted in *Textos de Orozco*, Mexico City, 1955.

In 1929, Diego Rivera wrote on subject matter in art — a question much debated in relation to Mexican mural painting:

And there is absolutely no reason to be frightened because the subject is so essential. On the contrary, precisely because the subject is admitted as a prime necessity, the artist is absolutely free to create a thoroughly plastic form of art. The subject is to the painter what the rails are to a locomotive. He cannot do without it.

'The Revolution in Painting', quoted in *Creative Art*, New York, January 1929, Vol. 4, No. 1.

SELECTED BOOK LIST

ART

The Art and Architecture of Mexico. Pedro Rojas. Paul Hamlyn, London 1967

Art and Architecture in Spain and Portugal and their American Dominions: 1500-1800. George Kubler, Martin Soria. Penguin, London 1959

The Art of Ancient Mexico. Paul Westheim. Doubleday, London 1965

The Arts of Ancient Mexico. J. Soustelle. Thames and Hudson, London 1967

Forty-five Contemporary Mexican Artists: a twentieth century Renaissance. Virginia Stewart. Stanford University Press, California 1952

HISTORY

The Ancient Past of Mexico. Alma Reed. Paul Hamlyn, London 1966

Aztecs of Mexico. G. C. Vaillant. Penguin, London 1965

A History of Mexico. H. B. Parkes. Eyre, London 1962

Mexican and Central American Mythology. Irene Nicholson. Paul Hamlyn, London 1967

Mexico. (Ancient Peoples and Places Series). M. D. Coe. Thames and Hudson, London 1962

Profile of Man and Culture in Mexico. S. Ramos. McGraw-Hill, New York 1963

Notes on the plates

Plate 1 *Dog Wearing a Mask.* Painted clay. Length 13 in. (33 cm.). Western Mexico ('Tarascan' culture). National Museum of Anthropology, Mexico City.

This figure, found in Colima, is an exceptional subject among the very large number of highly stylised and artistic clay figures produced by the Western Mexican culture. Fat-bellied dogs and other animals, as well as human figures in a variety of attitudes, are common in their funerary sculpture. The masked dog may possibly symbolise Xólotl, the god of death and brother of Quetzocóatl, disguised to accompany the dead to the world of after-life.

Plate 2 *Starving Dog.* Painted clay. Length 9¾ in. (25 cm.). From Colima. Western Mexico ('Tarascan' culture). National Museum of Anthropology, Mexico City.

Another funerary figure, like the fat dog in plate 1, but with the ribs showing as a result of starvation, and with an open mouth that suggests pain. These pottery figures symbolised the spirits of dogs which the Tarascans believed accompanied the dead into the after-life.

Plate 3 *Carved Stone Head of a Guacamaya Bird.* Votive *hacha.* Height 9¾ in. (25 cm.). Early classic period, from the centre of Veracruz state, National Museum of Anthropology, Mexico City.

Votive 'axes' (*hachas*) in a variety of forms, like the votive *palmas* (see plate 4), are a feature of the Gulf coast cultures. The so-called 'axes' are in fact beautifully carved blades of stone in the shape of human or animal heads with rich headdresses. The simplified forms and patterns are clear evidence of the highly developed art of the Gulf coast cultures. The exact purpose of *hachas* and *palmas* is still unknown, but may have been connected with funeral rites as they often depict the dead, or deities in animal form.

Plate 4 *Hands.* Votive *palma.* Stone. Height 16⅛ in. (40.9 cm.). Totonac culture. Tajín, Veracruz state. National Museum of Anthropology, Mexico City.

Many of these votive objects have been found in the region of the Gulf coast, largely belonging to the Olmec culture. This one is exceptional, its motifs and elegant formalised modelling being different in design from any others yet discovered. (See note on plate 3.)

Plate 5 *The Pyramid of the Niches.* 118 ft. (36 m.) along each side at the base; height approximately 81 ft. (25 m.). Probably Totonac, before the 9th century. Tajín, Veracruz state.

No other pyramid in ancient Mexico has the features of this early one at Tajín near the Gulf coast. Its characteristic rows of window-like niches — probably for votive offerings — facing each of the seven tiers are sandwiched between a base and a large jutting cornice. A deep-cut step-and-fret motif, the symbol of the serpent, forms the borders of the stairway that mounts the east side of the pyramid. The total number of niches (which continue underneath the stairs) is 364.

Plate 6 *Seated Figure.* Clay. Height 4 in. (10 cm.) Pre-classic Olmec. From Tlatilco, Mexico City. National Museum of Anthropology, Mexico City.

The head shows a deliberate deformation with the hair shaved off. The pressed-out lips and the down-turned corners of the mouth are the typical Olmec shape, forming what is called the 'jaguar mouth'. The figure as a whole is otherwise reminiscent of pottery sculpture of the archaic period which is found in the same part of central Mexico (see page 9), but the rather abstracted and stiff forms are unusual.

Plate 7 '*The Adolescent.*' Stone. Height 3 ft. 10 in. (116 cm.). Huastec culture. From near Tamuín, San Luis Potosí state. National Museum of Anthropology, Mexico City.

A superb figure in the round which apparently represents the god Quetzalcóatl as a young priest carrying his son on his back. Parts of the body have fine low reliefs, with symbols of maize, which he was supposed to have discovered for mortals. The elegance and harmony of its forms show an already assured sense of style. This is a unique piece, akin to a twentieth-century conception of art.

Plate 8 *Mask.* Jade. Height 4⅛ in. (10 cm.). Olmec culture. National Museum of Anthropology, Mexico City.

A baby's face, still showing traces of red colouring. It is crying and the shape of the mouth is rather similar to other carved Olmec faces (see plate 9). With its simplified forms and its expressiveness, this small mask is a gem.

Plate 9 *Colossal Head*. Stone. Height 8 ft. 2½ in. (249 cm.). Olmec culture. Park of the Museum at La Venta, Tabasco state.

Several heads like this have been found in the region. It represents a chieftain wearing a leather helmet, the symbol of authority. Its colossal proportions and the strong ethnic type are impressive. The mouth is shaped like a jaguar's (see plates 6 and 8).

Plate 10 *The Pyramid and Temple of the Inscriptions*. Height approximately 111½ ft. (34 m.). Maya culture. Palenque, Chiapas state.

The classic period of Maya culture extends from the fourth century A.D. to the middle of the ninth century. Palenque represents the peak of Mayan achievement. Among the many buildings within the site, interest has centred on the Temple of the Inscriptions. In 1950 a burial crypt under the pyramid was discovered which communicates with the upper levels by an internal stairway. A large slab with glyphs in low relief covered a sarcophagus containing the remains of a dignitary (probably a priest), together with various objects made of semi-precious stones. This is the first (and so far the only) case of a tomb being found underneath a pyramid in Mexico.

Plate 11 *Mask of Jade*. Mosaic. Height 9½ in. (24 cm.). Maya culture. From Palenque, Chiapas state.

Found in the sarcophagus under the Temple of the Inscriptions (plate 10). The mask originally covered the face of the dignitary buried there. It was found broken in pieces, but has been perfectly reconstructed with all the mosaic pieces put together. The long, straight nose is characteristic of Maya profiles. The eyes, with their life-like irises, are inlaid with mother-of-pearl and obsidian.

Plate 12 *Human Figure*. Painted clay. Height 7¹/₁₆ in. (18 cm.). Maya culture. Jaina, Campeche state.

From the little island of Jaina off the Gulf coast come a num-ber of fired clay figures of superb artistic quality and great character. The human figure reproduced here was actually a whistle. It was made from a mould, with small pieces of clay added later. The left hand holds a hat, and a small receptacle lies on the palm of the right hand. The piece is unique.

Plate 13 *The 'Church'* (*iglesia*). Chichén Itzá, Yucatán state.

One of the most striking buildings on the site of Chichén Itzá, this edifice is of the late, post-classic Maya culture, between the tenth and the middle of the thirteenth centuries, a period also known as 'Mexican', or Maya-Toltec, because of Toltec domination and the mixing of Toltec and Maya forms. The 'church' has the typical northern Maya cresting or false front on top of the main façade. The ornamentation is organised in bands, with key-pattern cornices, and large masks of the rain god Chac with his long nose. In the frieze are the four deities, called *bacabs*, which support the sky; they are disguised as a snail, a turtle, a crab and an armadillo.

Plate 14 *The Temple of the Tigers*. On the eastern platform the ball-game yard, Chichén Itzá, Yucatán state.

The use of Toltec forms is clear: the inverted plumed-serpent columns — such as were made two centuries before in the Toltec city of Tula, in the central highlands — are combined with a Maya architectural concept. 'Tigers' were warriors belonging to a military clan. The sacred ball-game was a ritual with a religious meaning. The flight of the ball symbolised the passage of the sun across the sky.

Plate 15 *Palace of the Governor*. Uxmal, Yucatán state.

Uxmal was thought to be a Maya-Toltec site as important as Chichén Itzá, but recent investigations give grounds for believing it to be much earlier, of the Classic Maya period, contemporary with Palenque. The building illustrated belongs to the Puuc style which flourished between the seventh and eighth centuries. It measures 321 ft. 6 in. × 39 ft. 4 in. (98 × 12 m.) and is 26 ft. 3 in. (8.60 m.) high. It is considered by many to be the most elegant example of pre-Hispanic architecture. The picture shows one of the two entrances to passages in the facade with the typical corbelled Maya arch,

treated very boldly. The lower body is plain, but the upper one is richly ornamented with a step-and-fret design in the Mexican Toltec manner. Masks of the rain god Chac, with a long nose, decorate the angles.

Plate 16 *Vessel with a Bird*. Painted clay. Height 3 in. (8 cm.). Mixtec culture. From Zaachila, 7 miles south of the town of Oaxaca, Oaxaca state. 15th century (?). National Museum of Anthropology, Mexico City.
One can see here the elements of Mixtecan design and colouring in the decoration of pottery which may have been taken over by the Aztecs. A similar decorative influence is traceable to Mixtec manuscripts. This small receptacle is exceptional because of the humming bird perched on its lip.

Plate 17 *Vessel with a Skeleton*. Clay. The skeleton is just over 12 in. (31 cm.) in height. Mixtec culture. From Oaxaca. 15th century (?). National Museum of Anthropology, Mexico City.
The image of death appears in Mexican art in one way or another from the earliest period to the present time. There is considerable elegance in the simplified and expressive forms of this extraordinary vessel. As so often in pre-Hispanic art, the skeleton is shown as if it were alive.

Plate 18 *Necklace* (gold, coral, turquoise, pearls). Mixtec culture. From Tomb 7, Monte Albán, Oaxaca state. 15th century. State Regional Museum of Archaeology, Oaxaca.
Of all the magnificent jewellery of pre-Hispanic times that of the Mixtecans is particularly fine, like this beautifully designed necklace with little gold bells at the bottom, which comes from a hoard of gold objects, and others in precious materials which had been hidden in one of the tombs at the earlier Zapotec site of Monte Albán.

Plate 19 *Gold Pendant*. Height 4¼ in. (11 cm.). From Tomb 7, Monte Albán, Oaxaca. Mixtec culture. 15th century. State Regional Museum of Archaeology, Oaxaca.
One of the most extraordinary gold pieces from pre-Hispanic Mexico. Few gold objects have survived, and the best are Mixtecan, like this breast-pendant, overwhelmingly expressive and of high technical accomplishment. It is cast by the *cire perdu* method, with additions soldered on, and represents 'the Lord of Death' (Mictlantecuhtli), recognisable by the fleshless jaws. On his breast he bears the signs of two dates, and an elaborate headdress frames his face.

Plate 20 *Decorated Walls*. Mitla, Oaxaca state. Late Zapotec, about the 14th century.
The temples and palaces at Mitla (Mictlan, the 'place of the dead') are unique in their plan, and particularly so in the geometric designs on the walls. These patterns are mostly variations of the widespread step-and-fret motif. The technique of applying them to the wall is peculiar: small blocks, perfectly cut, were encrusted like bricks on to the surface. The effect of the abstract panels on the interior and exterior walls is superb. The buildings are not high, and consist of rooms surrounding a courtyard.

Plate 21 *Pyramid of the Sun*. Teotihuacan ('the place of the gods'), 30 miles (50 km.) north-east of Mexico City. Height approximately 207 ft. (63 m.). 4th to 9th centuries.
Several periods can be distinguished during the long flourishing of Teotihuacan culture, which goes back to an archaic horizon before the Christian era. There is evidence of two distinct conceptions of form and style: an earlier one with exuberant ornamentation, as in the Pyramid of Quetzalcóatl (plate 22); and a later one with severe, classic forms, which is the style of the Teotihuacan we now see in all its majesty — the Pyramid of the Sun (as illustrated here), the 'Citadel' and the buildings lining the Avenue of the Dead, and the Pyramid of the Moon closing it to the north. The layout of Teotihuacan on its grid, angled from the axis of the Avenue of the Dead, is a superb example of architectural harmony. Recently much work has been done to bring Teotihuacan back to its original state and splendour as far as possible. Excavations have uncovered still more buildings, such as the Palace of the Quetzalpapálotl (plate 23), and restorations now enable the visitor to visualise the magnificence of this ancient site of pre-Hispanic Mexico. Apart from the monuments, there are a number of painted interior walls, for example some very attractive ones in the nearby palace of Tepantitla.

Plate 22 *Plumed Serpent*. Detail of the Pyramid of Quet-

zalcóatl, Teotihuacan.

This pýramid, near the south end of the Avenue of the Dead, belongs to the earlier period referred to in the note on plate 21. The god Quetzalcóatl (meaning 'the quetzal-bird of the south') appears repeatedly in the guise of the Plumed Serpent on the various faces of the pyramid, alternately with Tláloc, the god of the rains. Quetzalcóatl, a beneficent god, may in this case be understood as the god of spring. The aggressive heads of the Plumed Serpent are magnificent, the eyes are obsidian, and there are a few traces of colouring.

Plate 23 *Mural Painting of Tigers*. Classic or late period at Teotihuacan.

This fragment of a fresco was discovered and restored not long ago in a room next to the so-called Palace of the Quetzalpapálotl ('Quetzal-bird butterfly'). The elegantly drawn tigers, wearing rich feather headdresses and masks, are either howling or singing. Throughout the pre-Columbian Americas, the tiger was a sacred emblem.

Plate 24 *The Stone of the Sun*, or 'Aztec Calendar'. Olivine basalt. Diameter 11 ft. 9¾ in. (360 cm.). Maximum thickness 2 ft. 4⅜ in. (72 cm.). Weight 25.5 metric tons. The relief is 7⅞ in. (20 cm.) deep. Aztec culture. 15th century. From the Plaza of Mexico City. National Museum of Anthropology, Mexico City.

This is perhaps the most popular piece of sculpture from pre-Hispanic Mexico, and is known all over the world. The compact and balanced design and carving of the powerful reliefs still show up well. The face of the sun-god Tonatiuh ('earthquake') is shown in the centre. Four rectangles around him contain the symbols of the four previous suns, named 'wind', 'tiger', 'rain', 'water'. The Aztecs believed that they were living in the age of the fifth sun which would destroy humanity. The first complete ring shows the symbols of the twenty days; in a further ring, are the stars, and finally the sky. These two last rings are pierced by triangular shapes which represent either constellations or possibly the rays of the sun. The outer ring consists of two serpents of fire with their heads at the bottom. The date, 13-*Reed*, referring to the birth of the present solar god (see page 24), is placed between the tail-tips of the two serpents at the top.

Plate 25 *Coatlícue*. Olivine basalt. Height 8 ft. 6⅜ in. (260 cm.). Weight 16.5 metric tons. Aztec culture. 15th century. From the Plaza of Mexico City. National Museum of Anthropology, Mexico City.

Aztec sculpture is seen here as comparable in its power with that of the classic Oriental cultures. Coatlícue is one of the greatest monoliths to have survived the centuries following the Spanish Conquest, when so much was destroyed for religious reasons. It lay buried in the Plaza and was found late in the eighteenth century, at the same time as and not far from the *Stone of the Sun* (plate 24). She is renowned as the goddess of the earth, as 'she of the serpent skirt', which is what her name means. But actually she is much more, she is a summary of the cosmology of ancient Mexico. Her complicated symbolism has reference to the sun as an eagle (her legs and feet as claws); to the life of mortals (her skirt of knotted snakes); to deities (her belt, arms and claws); to death (her skull pendant); to human sacrifice (her necklace of hands and hearts); to spring (her breasts); and to the cosmic principle of duality, masculine and feminine (the two rattlesnakes' heads which sprout from her neck). On her back are the symbols of the thirteen skies and a reference to her son Huitzilopochtli, the war god and patron of the Aztec nation. With its extraordinary forms, the statue of Coatlícue is unique in the history of world art.

Plate 26 *Stone of Tizoc*. Detail of the rim of a circular block of olivine basalt. Diameter 8 ft. 6⅜ in. (260 cm.). Height 2 ft. 10⅝ in. (88 cm.). Weight 16.5 metric tons. Aztec culture. 15th century. From the Plaza of Mexico City. National Museum of Anthropology, Mexico City.

This monolith, which has a cup and gutter carved on the top, is supposed by some to have been a sacrificial stone, or a receptacle for human hearts and blood (a Cuauhxicalli or 'eagle vessel'). Regardless of whatever its use may have been, it is in itself inscribed with the name and conquests of the great Aztec chieftain Tizoc (1483-6). The relief-frieze around its rim shows scenes of victorious warriors leading their captives by the hair. The quality of the relief and the harmonious composition are unmistakeably those of a highly developed art and culture.

Plate 27 *Plumed Coyote*. Olivine basalt. Height 1 ft. 3¾ in. (40 cm.). Aztec culture. 15th century. From the Valley of Mexico. National Museum of Anthropology, Mexico City. The image of a coyote covered with feathers is a symbolic combination which indicates that this represents a deity (possibly Quetzal-coyote or Hueline-coyote, the ancient god of fire) wearing a disguise of precious feather-work. The ferocious yet calm expression of the creature is superb, and the whole design is most harmonious.

Plate 28 *Façade of the Church at Acolman*. 1560. Mexico, D.F. Acolman lies about 24 miles (40 km.) north-east of Mexico City on the highway to Teotihuacan. The name of the place is a Náhuatl word meaning 'arm with elbow' — a reference to an Indian legend. This emblem appears in one of the shields on the façade of the church, which is part of the convent founded here by the Augustinian friars in 1539. The whole enclosure, with the church and calmly elegant cloisters, is full of interest.

While the apse of the vaulted interior of the church is Gothic, the façade, seen in this plate, with its ornamental pilasters, its statues in niches, its frieze and roundels and candlesticks, and the double-arched porch, is the best example in Mexico of the Spanish form of Renaissance architecture known as Plateresque. This word comes from *platería*, and is suggested by the resemblance that this style has to silver-smith's work. The carving, which shows no traces of Indian interpretation, was probably carried out by skilful Indians trained and directed by the friars.

Plate 29 *Cloister of the Convent at Acolman*. 1550-60. Mexico, D.F.
Like the façade of the church (plate 28), the elegant cloister of the Augustinian convent at Acolman is regarded as one of the finest examples of its kind. Arches and columns reminiscent of Romanesque support the gallery and the roof-beams. The parapet of the upper storey is also medieval in style. The spandrels between the arches carry monograms and emblems of the Augustinian order. Black and white frescoes line the gallery.

Plate 30 *Wall Painting in the Conventual Church of Ixmiquilpan.*

Fresco. Mid-16th century. Hidalgo state.
Most of the first religious houses established in Mexico were originally decorated with monochrome frescoes, often painted by native artists under the direction of the friars. The subjects were usually copied from or suggested by European engraved book illustrations, and painted, like them, in black and white. But the friary at Ixmiquilpan is unique, for when it was founded by the Augustinians it was decorated inside with polychrome frescoes including depictions of Indians, as in post-Hispanic codices, though these frescoes were later painted over. The walls of the church have recently been cleaned and some very attractive paintings have come to light, with exceptionally subtle colours. This detail shows Indians fighting against monsters.

Plate 31 *Detail of the Reredos of the High Altar in the Church of Xochimilco*. About 1570, near Mexico City.
The Augustinian friars had founded their house at Xochimilco (famous for its canals and floating flower-gardens) by the middle of the sixteenth century. The magnificent *retablo mayor* (reredos) is one of the few in Late Renaissance style to survive. It is in carved wood, partly gilt and painted. The central image of the Virgin is probably the finest example of Renaissance sculpture in colonial Mexico. The drapery is gilt all over and painted with a delicate pattern in *estofado* (the technique, typical of Spanish polychrome sculpture, of imitating gold brocade by pricking or scratching the paint away to reveal the gold-leaf underneath). The figure has the grave beauty of classical idealism.

Plate 32 Sebastián López de Arteaga *The Incredulity of St Thomas*. 1643. Oil on canvas. 7 ft. 5 in. × 5 ft. 1½ in. (226 × 156 cm.). Pinacoteca Virreinal, Mexico City.
The seventeenth century was the golden age of colonial painting in New Spain.

The composition of this *St Thomas*, with its life-size figures, is excellent. The semi-nude Christ has a tenderness that is all in keeping with the spirituality with which the scene is suffused. The picture is a particularly beautiful example of Mexican painting of its period.

Plate 33 José Juárez *The Adoration of the Kings (Epiphany).*

1655. Oil on canvas. 8 ft. 6⅜ in. × 5 ft. 4³/₁₆ in. (2.60 × 1.63 m.). Pinacoteca Virreinal, Mexico City.

Mannerist painting was established in Mexico by the Spanish master Baltasar de Echave Orio (c. 1548 — 1620). An aristocratic Basque by birth, he went out to New Spain in about 1573. He found a successor there in his Mexican-born pupil Luis Juárez, whose son, José Juárez (c. 1615 — 1667), became in turn a pupil of Arteaga (plate 32), from whom he learned to use the Baroque *chiaroscuro*. Neither José nor his father ever went abroad. *The Adoration of the Kings* confirms José as Mexico's outstanding High Baroque painter.

Plate 34 *Detail of the Chapel of the Rosary in the Church of Santo Domingo*. About 1690. Gilt and polychrome stucco. Puebla, Puebla state.

The city of Puebla was the home of a school of fine craftsmen in gilt and painted stucco whose work is found in many parts of the country where the colourful ornamental Puebla style had spread — notably to the south. The chapel of the Rosary, which was completed in 1690, is a superb example of their elaborate moulding as it swamps all structural lines, even in the vaulting and the cupola.

The view in this detail conveys an idea of the richness of the stucco, but the truly marvellous effect of the whole can be appreciated only by making a visit to the chapel.

Plate 35 *Façade of the Cathedral of Zacatecas*. First half of the 18th century. Zacatecas state.

Originally built in 1579 as the parish church of this fabulously rich silver-mining town, Nuestra Señora de la Asunción was later elevated to the rank of cathedral. The façade was completed only in 1752, but retained the forms which had flourished in the previous century — for instance, the twisted Baroque 'Solomonic' columns. The round window is still in the spirit of a medieval rose window, while the general effect of the heavily encrusted surface is one of great magnificence.

Plate 36 *The Altar in the Chapel of the Kings, Mexico Cathedral*. First half of the 18th century.

This chapel, the *capilla de los santos reyes* near the high altar of the cathedral in Mexico City, is like a fantastic grotto of gold, and entering it the beholder seems to be carried into another world. The altar and reredos, built between 1718 and 1737 by Jerónimo de Balbás, and gilded in 1743, was the first structure to be seen in New Spain in the late Baroque style called 'Churrigueresque' after the Spanish architect José de Churriguera (see page 15). A better term for this splendidly luxuriant style is 'ultra-Baroque', as it goes farther than any other style in the use of Baroque forms. The typical feature of ultra-Baroque is the dissolved contour and the use of a column, thick at the top and narrowing at the base, like an inverted obelisk, called an *estípite*. Architectural forms practically disappeared under the profusion of ornament, sculpture and paintings.

Plates 37 and **38** *The Church of San Francisco at Acatepec*. 18th century. Puebla state.

Acatepec church, not far from Tonantzintla (see plate 39), is an example *par excellence* of the *poblano* ('of Puebla') style, which is based on the use of polychrome tiles manufactured in Puebla. These tiles completely encase the baroque form of the façade. The colourful effect can be seen in the detail in plate 38.

Plates 39 and **40** *Interior of the Church of Santa María at Tonantzintla*. 18th century. Puebla state.

Although the architectural form is classical, the ornamentation which encrusts every square inch of the interior is in the popular taste. Tonantzintla church is an example of the lengths to which the painting and gilding of stucco could be taken in the desire to turn the place of worship into a kind of jewelled grotto. A detail of heads, masks and floral motifs is shown in plate 40.

Plate 41 *The Sanctuary of the Virgin at Ocotlán*. 18th century. Tlaxcala state.

The architecture of Puebla and Tlaxcala developed along parallel lines. The red tiles on the sanctuary of Ocotlán, just outside the city of Tlaxcala, are set off in contrast by the blinding white of the painted stucco. The soaring twin belfries give distinction to the building, framing the scallop-

topped façade between them. The statue of the Virgin outside the star-shaped end window is an original idea.

Tlaxcala was a peaceful conquest of the Spaniards, and the Tlaxcaltecs opened their gates to Cortés and his forces on September 23rd, 1519. Charles V conferred on it a charter and the title 'very noble city' — the first in the Americas to be honoured in this way. Tlaxcala was the first missionary centre of the Catholic faith in the Spanish dominions. The sanctuary of the Virgin dates from these early days of the conquest.

Plate 42 '*Casa de Alfeñique*.' 18th century. Puebla, Puebla state.

There is much fine civic architecture in Puebla de los Angeles (now Puebla de Zaragoza). This city was founded by the Spanish colonists on an entirely new site and has no Indian origin. The glazed coloured tiles alternating with matt red ones produce an interesting effect that is typical of the Puebla style. The *Casa de Alfeñique* ('Sugar-candy House') with its characteristic balconies and overhanging decoration, is a well-preserved example of an eighteenth-century building in Puebla.

Plate 43 *The Museum of Mexico City* (Casa de los condes de Santiago de Calimaya). 1774-9. Mexico City.

This large building, the old mansion of the Counts of Calimaya at 30, Avenida J. M. Pino Suárez in Mexico City, is one of the best surviving examples of colonial architecture in a private house. Originally built in 1528 for a cousin of Cortés, it was rebuilt in the eighteenth century in a restrained Baroque style. It has recently been converted into the Museum of Mexico City. The walls are faced, like so many colonial buildings, with red pumice, called *tezontle*. An Aztec sculpture of the head of a plumed serpent was built into one corner. Another name given to this mansion was *Casa de los cañones*, on account of the rain-spouts shaped like cannon.

Plate 44 José María Velasco *Mexico*. 1877. Oil on canvas. 5 ft. 1 in. × 7 ft. 4½ in. (155 × 225 cm.). Museum of Modern Art, Instituto Nacional de Bellas Artes, Mexico City.

The teaching of the Italian painter Eugenio Landesio, who had been invited to Mexico under the régime of General Santa Ana to join the staff of the revived Academy, became the origin of a school of landscape painting which flourished in the second half of the nineteenth century. Velasco (1840 – 1912) surpassed the work of his master and created, with his series of broad vistas, an impressive vision of the landscape of his country. He subtly introduced the idea of history into his compositions by including in them archaeological sites and colonial monuments, and expressed the idea of progress by depicting the railway line to Veracruz in his views. Of his many versions of the Valley of Mexico, this large canvas entitled *Mexico* is his masterpiece. It looks down from the north, with the distant city in the background. Lake Texcoco and the volcanoes lie to the left. The apparently naturalistic details of the swooping eagle and the cactus in the foreground are, in fact, the symbols of the nation of Mexico, so that the picture is as much an allegory while being, at the same time, a very fine landscape.

Plate 45 Saturnino Herrán *The Offering* (*la ofrenda*). 1913. Oil on canvas. 6 ft. × 6 ft. 11 in. (183 × 210 cm.). Museum of Modern Art, Instituto Nacional de Bellas Artes, Mexico City.

The first steps towards modern art, coinciding with the overthrow of academic rule associated with the pre-revolutionary régimes of Mexico, were taken by assimilating Post-impressionist techniques, and particularly the influence of Gauguin. The movement of 'syntheticism' (see page 18) is best represented by the work of Herrán (1887 – 1918), who introduced into painting not only new forms of expression but also the new subject matter of Mexican life. This large canvas shows a canoe on a canal at Xochimilco, bearing a family with their offerings of yellow *zempasúchil* flowers for the dead. Herrán portrayed Indian and Creole types with truth and real feeling.

Plate 46 Diego Rivera *Man Masters the Elements*. 1927. Fresco. Salón de Actos (Auditorium) of the National Agricultural School at Chapingo, Mexico D.F.

The frescoes at Chapingo, to the east of Mexico City, are probably Rivera's greatest achievement. The Agricultural School is established in what used to be an old colonial

hacienda or plantation house, and the Auditorium was the former chapel, a barrel-vaulted Baroque edifice. Rivera (1886 — 1957) painted a series of panels along both walls, taking as his theme, on the right, 'the biological development of the human being' and, on the left, 'the evolution of society'. These meet on the end wall in a centrepiece where man is shown as having harnessed the elements, or forces of nature, by means of science and technology. The earth is represented by a large female nude with the winds blowing over her back, while water-power is represented as another female nude below at the left (hydro-electric power) and fire emerges from a volcano below at the right. Mankind is represented by a nude Mexican family in the foreground, the child holding up the symbol of electrification.

Plate 47 Diego Rivera *Mother Earth Asleep* (*la tierra dormida*). 1929. Fresco. Salón de Actos (Auditorium) of the National Agricultural School, Chapingo, Mexico D.F.
This poetic image of the sleeping earth with her hidden powers of reproduction and growth is one of the great reclining nudes in world painting. The firmness and delicacy of the forms, the pointillistic technique with small brush strokes, the sensitive colouring, the mysterious, sensual head and the symbolism of the maize-seed sprouting within the shelter of the woman's hand (compare with plate 46) make this painting a twentieth-century masterpiece.

Plate 48 Diego Rivera *The Market Place of Tenochtitlan-México* (detail). 1942. Fresco in the corridors of the Palacio Nacional, Mexico City.
The decoration of the presidential palace — formerly the viceregal residence, built on the site of Moctezuma's palace — was put in hand in the early nineteen-thirties. Rivera finished his frescoes for the grand staircase, one of his major works, in 1935. These were his interpretation of the history of Mexico from the Indian past to the present. From 1942 onwards he undertook, in the corridors of the palace, a new series of frescoes covering the pre-Hispanic period, ending with the Conquest. He never embarked on the continuation down to modern times. The detail reproduced here is an imaginative and colourful reconstruction of life in Tenochtitlan (the ancient Aztec name for Mexico City). The city

and the volcanoes dominate the background, with the great pyramid and the temples of the rain god Tláloc and of the war god Huitzilopochtli. Rivera's vision lies somewhere between fact and poetry.

Plate 49 José Clemente Orozco *Cortés and Malinche*. 1926. Fresco. National Preparatory School of San Ildefonso, Mexico City.
One of Orozco's early frescoes, this image of the Spanish conqueror Hernán Cortés with the native girl 'Malinche' (Malintzin) — his mistress, guide and interpreter — is particularly significant as symbolising the blending of the two races. Orozco (1883 — 1949) conceives the couple in the nude, carnal, powerful and majestic. At their feet lies the subjugated race. This fresco is one of a series presenting the new culture which came about as a result of the Spanish conquest.

Plate 50 José Clemente Orozco *Hernán Cortés*. 1939. Fresco in the soffit of the vaulted ceiling of the Salón de Actos (Auditorium) of the Instituto Cabañas, Guadalajara, Jalisco state.
This superb image of Cortés as a terrifying machine forms a contrast with the *Cortés and Malinche* of 1926 (plate 49). Both have power, but whereas the earlier vision stresses its dignity, the later one abounds with a sense of the violence of the Spanish conquest and stresses the aspect of modernity — Cortés the conqueror, in body armour and sword in hand, is also the precursor of the modern industrial age. A spirit descends from above to whisper in his ear — his daemon or his genius, who can tell? — while Cortés pauses in his stride over the mutilated bodies of the vanquished Indians.
The Instituto Cabañas is an old orphanage in Guadalajara, the second city of Mexico and capital of the state in which Orozco was born.

Plate 51 José Clemente Orozco *Man of Flames*. 1939. Fresco in the cupola of the Salón de Actos (Auditorium) of the Instituto Cabañas, Guadalajara, Jalisco state.
No other work sums up Orozco's tragic sense of life better than this one. Having treated history and the various circumstances that affect human life and development, he crowns and summarises all with this allegory of the human

condition. It can be interpreted in several ways. Three dark male figures, each in a different posture (three different attitudes to life), form a circle through which a central figure soars, a man consumed by flames. His is the final answer: to live is to burn oneself up. There are no parallels in world art for this conception. It is Orozco's masterpiece and a supreme achievement of twentieth-century monumental painting.

Plate 52 David Alfaro Siqueiros *Self-portrait*. 1943. Pyroxylin on celotex. 3 ft. × 3 ft. 11½ in. (91 × 121 cm.). Museum of Modern Art, Instituto Nacional de Bellas Artes, Mexico City.
Siqueiros (born 1896) has been a great promoter of mural painting in Mexico and has helped the original movement of the 'twenties to continue its progress. He insists on the exploration of new methods and materials and the application of new social ideas. His own works count as some of the most important of their kind. His powerful expressionism and vigorous personality are very evident in this self-portrait.

Plate 53 Rufino Tamayo *Homage to the Race* (*Homenaje a la raza*). 1952. Vinylite on masonite. 16 ft. 4⅞ in. × 13 ft. 1½ (5 × 4 m.). Museum of Modern Art, Instituto de Bellas Artes, Mexico City.
This mural was commissioned for the exhibition of Mexican art which was seen in Paris, Stockholm and London in 1952-3. The originality of Tamayo (born 1899) lies in his forms and colour. Abstract but always meaningful, his work is profoundly human. He is able to suggest feelings and ideas through imaginative means. The richness of colour and the formal strength of this flower-seller mark it as the work of a master of twentieth-century painting.

Plate 54 *Sugar Fish*. 20th-century popular art. Length 2¾ in. (7 cm.). National Museum of Popular Arts and Crafts, Instituto Nacional Indigenista, Mexico City.
The craftsmen of Mexico are often true but anonymous artists expressing themselves in traditional ways. The most exquisite objects come from their hands. Some are for every-day use and some, like this little painted sweetmeat, full of character and tenderness, merely for the fun of making a thing of beauty.

Plate 55 *Sugar Skull*. 20th century popular art. Height 4¾ in. (12 cm.). National Museum of Popular Arts and Crafts, Instituto Nacional Indigenista, Mexico City.
Images of death run constantly through Mexican art (see plate 17). The subject is not a gloomy one in the Mexican imagination, and folk artists use death (mainly represented as a skeleton) in many sorts of children's toys. It is, above all, the custom on the 'day of the dead' (All Souls', November 2nd) to make presents of edible sugar skulls, often with the individual's name inscribed on the forehead in icing and with fanciful adornments to give them a cheerful appearance.

Plate 56 *Lacquer Tray*. Polychrome lacquer on wood. Diameter 1 ft. 11⅝ in. (60 cm.). From Michoacan state. National Museum of Popular Arts and Crafts, Instituto Nacional Indigenista, Mexico City.
Fine lacquer-ware in shellac and sumac, hand-worked and burnished, and with a superb finish, has been produced in Mexico since the seventeenth century. The centre for this work is in Michoacan state on the Pacific coast, whose inhabitants are mainly Indians descended from the creators of the Tarascan culture (see page 10). Modern designs still retain the charm of the traditional models.

Plate 57 *Quechquémitl*. Woollen embroidery. National Museum of Popular Arts and Crafts, Instituto Nacional Indigenista, Mexico City.
This cape, with a square hole to put the head through, is the typical outer garment worn by Indian women in many regions of Mexico, and it has also become fashionable wear for the wealthy classes. An endless variety of geometric designs can be found in *quechquémitls*, as each piece is hand-worked in free improvisation on certain traditional rules and techniques.

Plate 58 *Candelabrum*. 20th century popular art. Polychrome earthenware. Height 2 ft. 3½ in. (70 cm.). From Metepec, Mexico state. National Museum of Popular Arts and Crafts, Instituto Nacional Indigenista, Mexico City.
Clay objects from Metepec are quite distinctive, and this candelabrum is a good example of the wealth of fantasy possessed by Metepecan folk-artists. With Adam and Eve,

the serpent, cherubs and an angel at the top, not to mention the birds, rabbits and flowers, it is a naive image of paradise, exuberant and joyful.

Plate 59 *Mask.* Carved and painted wood. 17th century. Height 2 ft. 5½ in (75 cm.). National Museum of Popular Arts and Crafts, Instituto Nacional Indigenista, Mexico City. With its dark features and rudimentary helmet, Baroque design and broad characterisation, this is probably a Colonial example of a mask for the 'Moors' Dance', introduced into Mexico by the friars early in the sixteenth century.

The origin of this ritual dance goes back to the cult of St James of Compostela in Spain, the patron saint of the Christians in their struggle against the Moors. The friars adapted it for the Indians. The masks represent the fair-skinned Christians and the dark-skinned Moors. The costumes were rich and fantastic. This is essentially a Mestizo dance: European in conception but, in performance, Indian in spirit. It is still performed, particularly in the states of Michoacan, Morelos, Mexico and Veracruz, with local variations of costume and choreography.

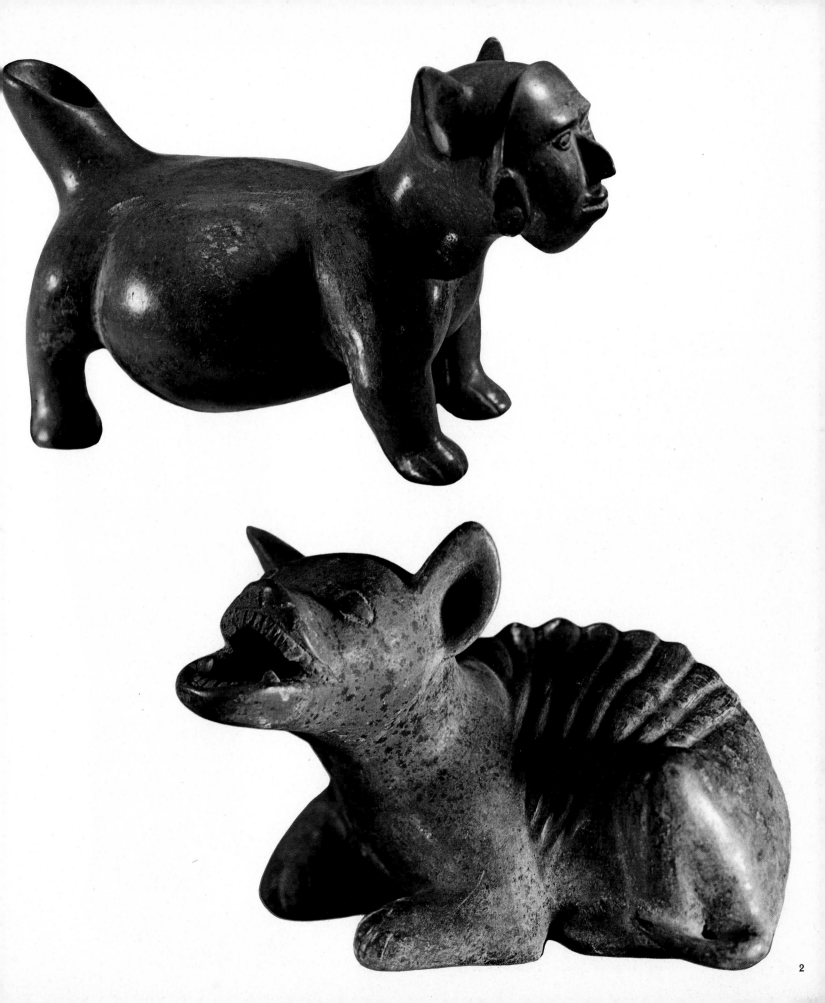

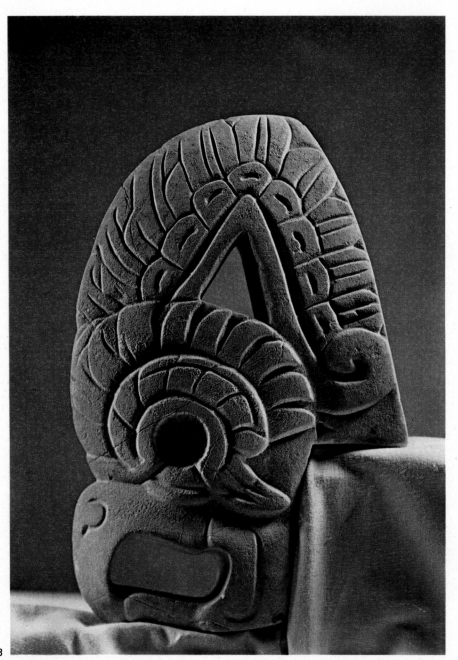

3

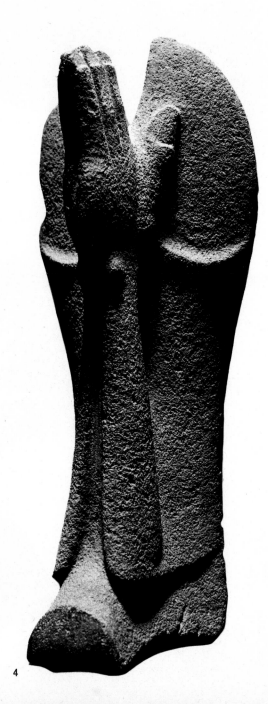

4

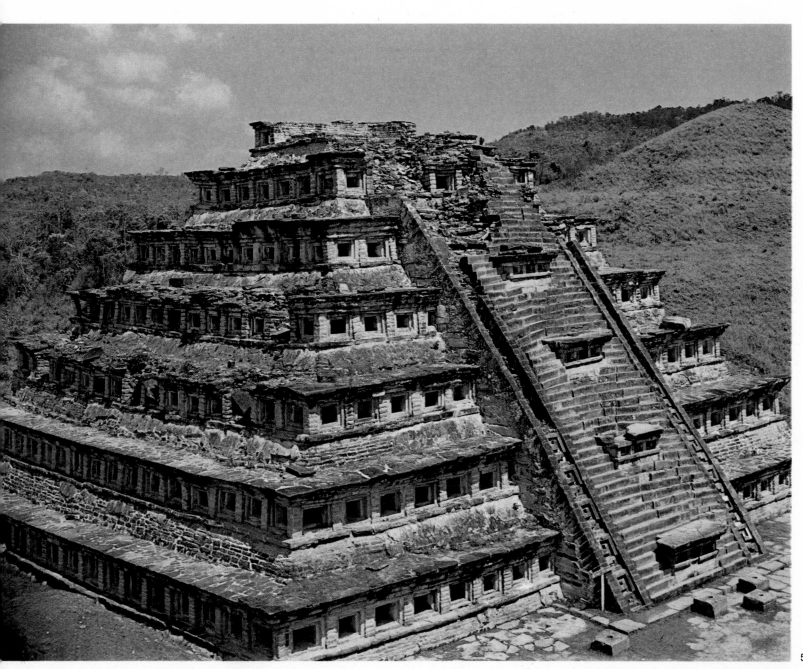

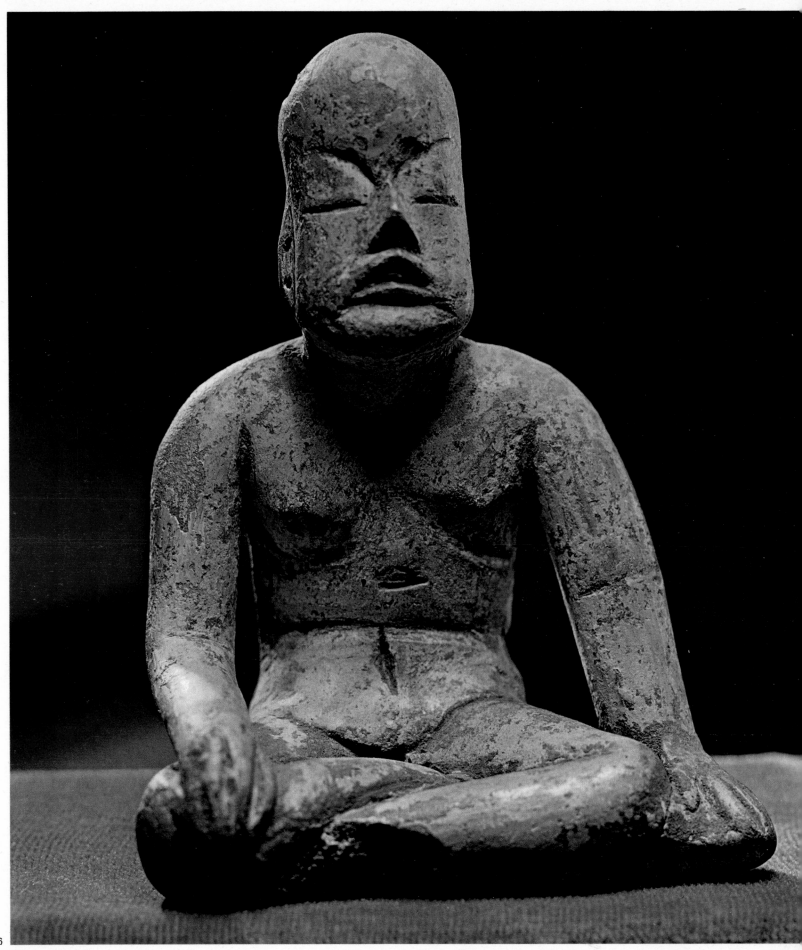

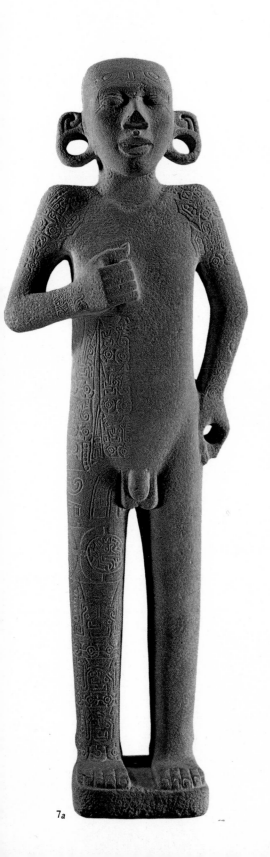
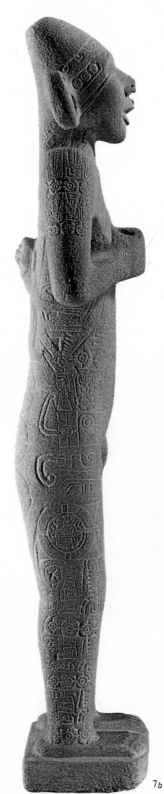
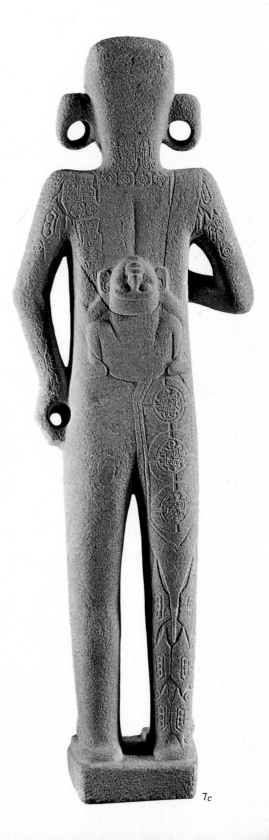

7a 7b 7c

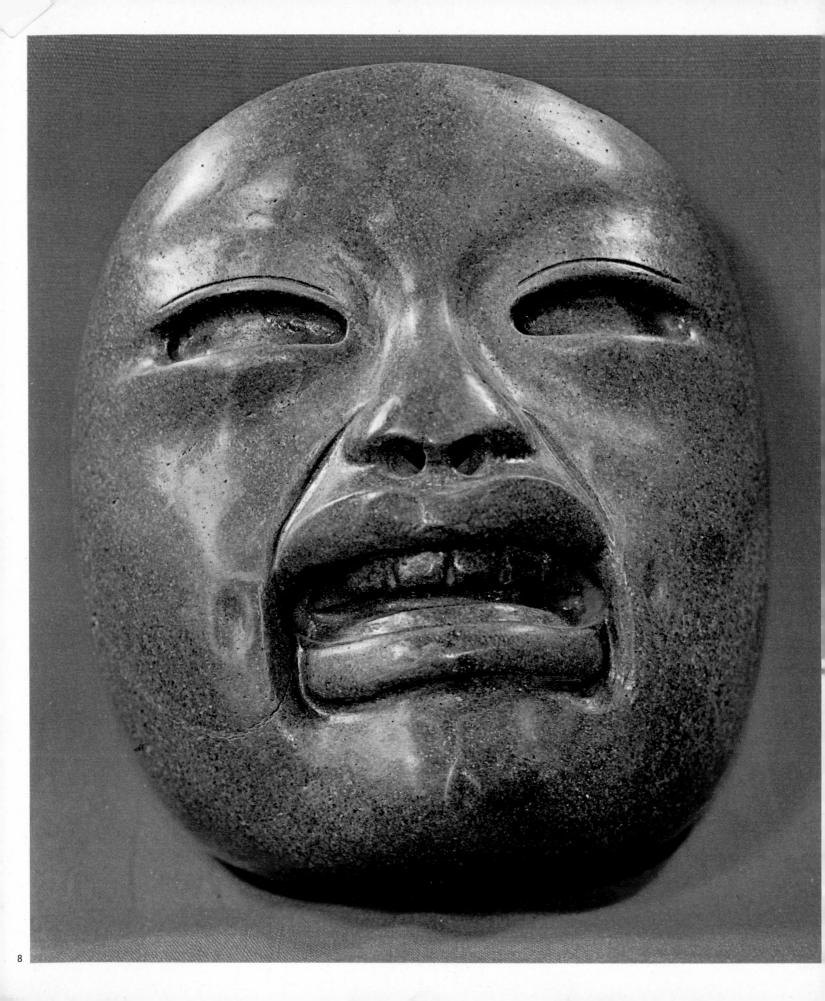

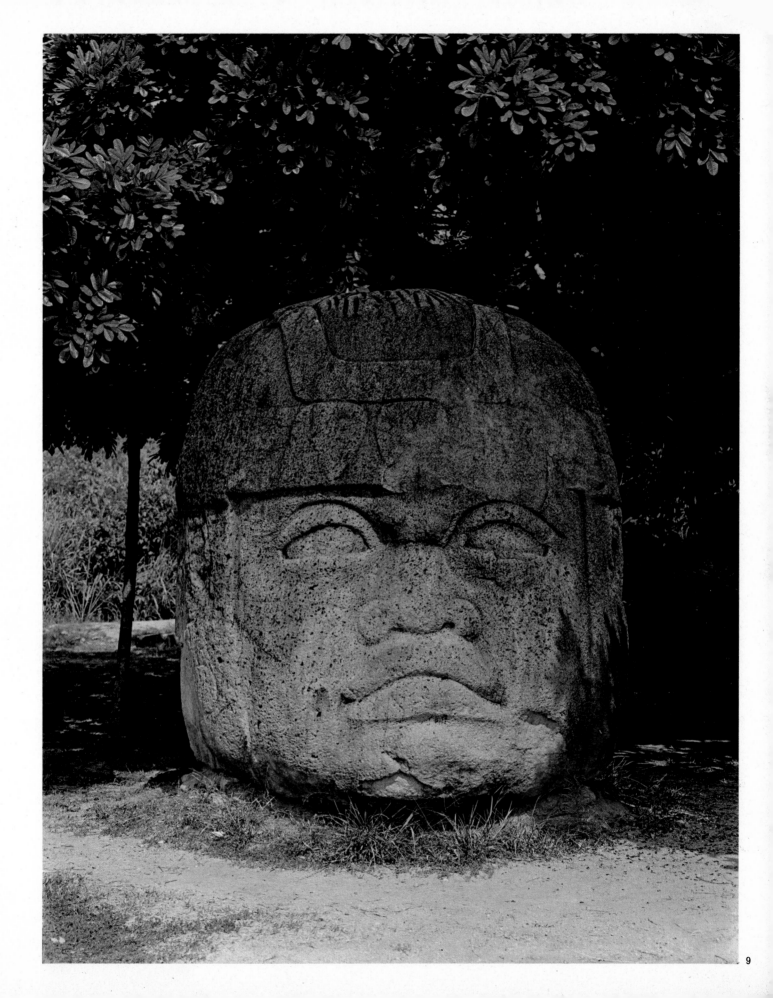

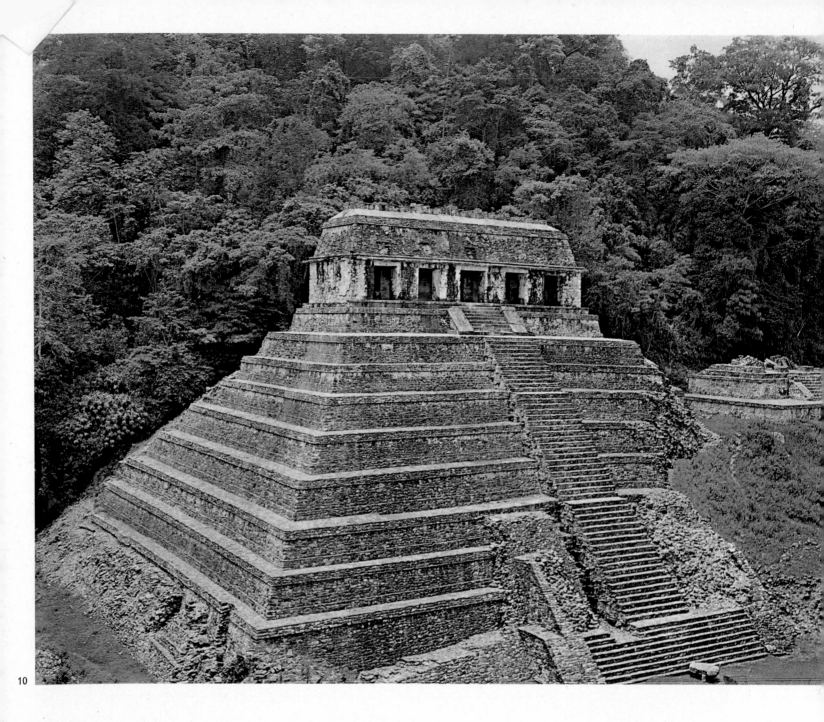

10

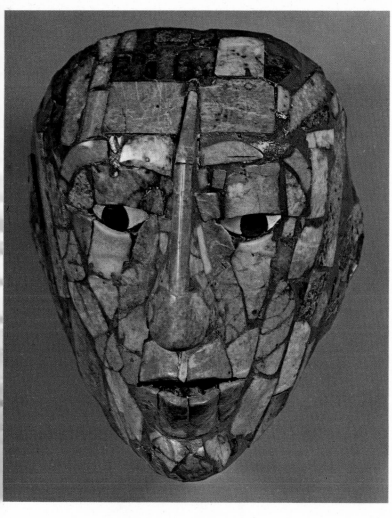

11

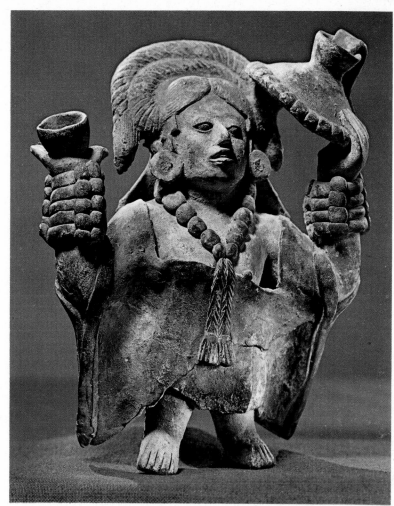

12

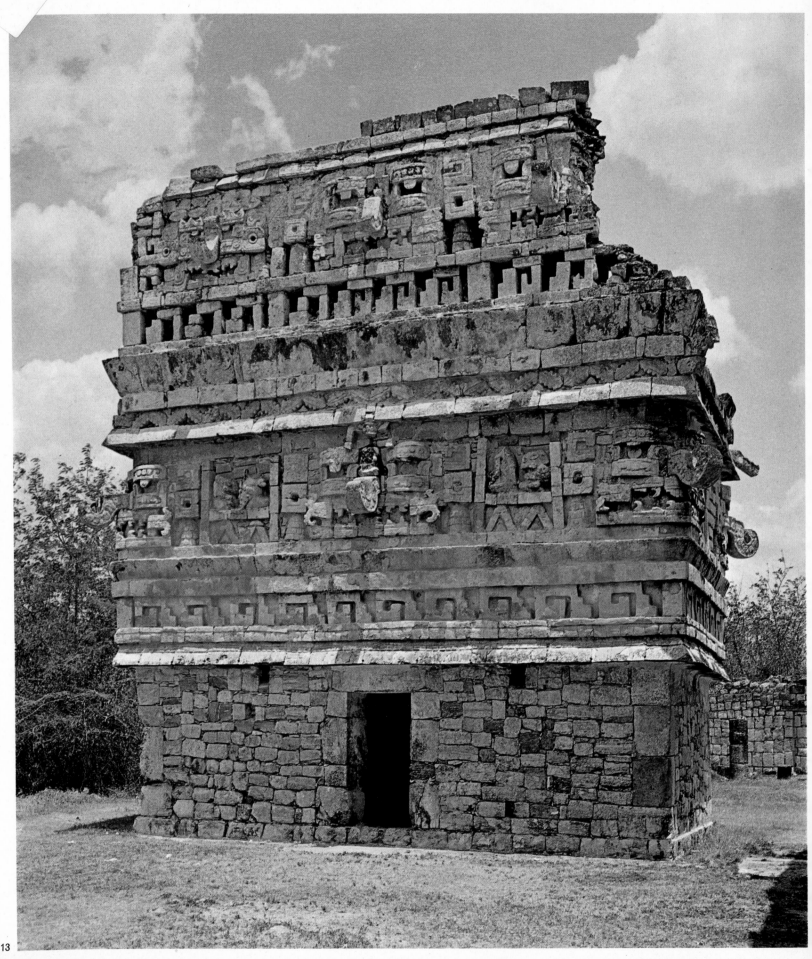

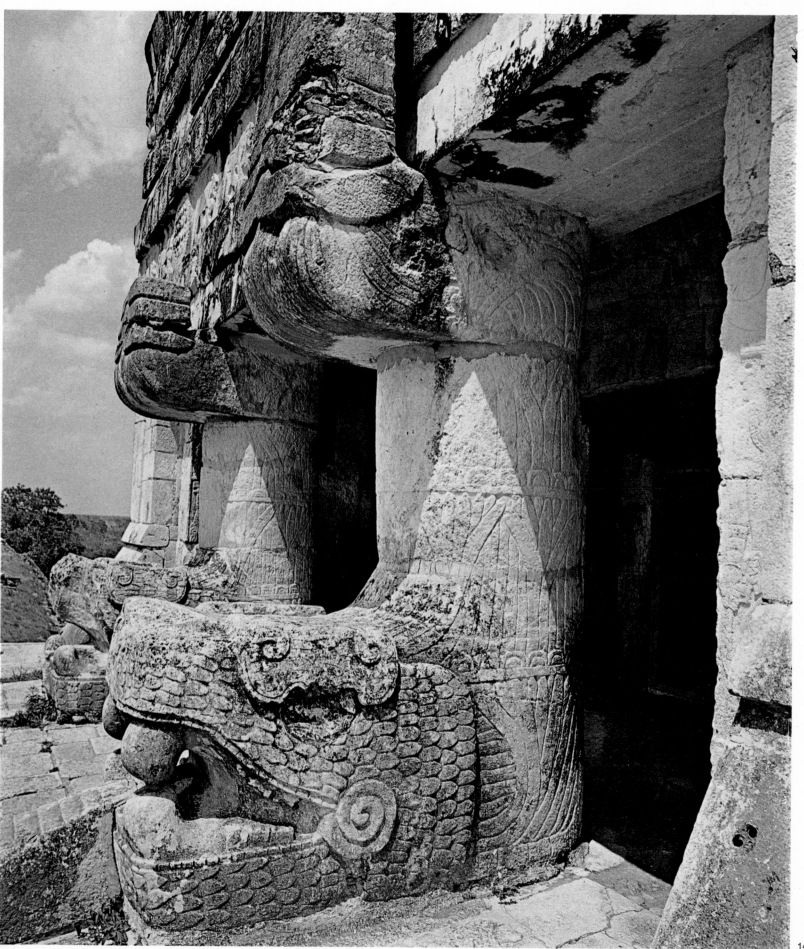

14

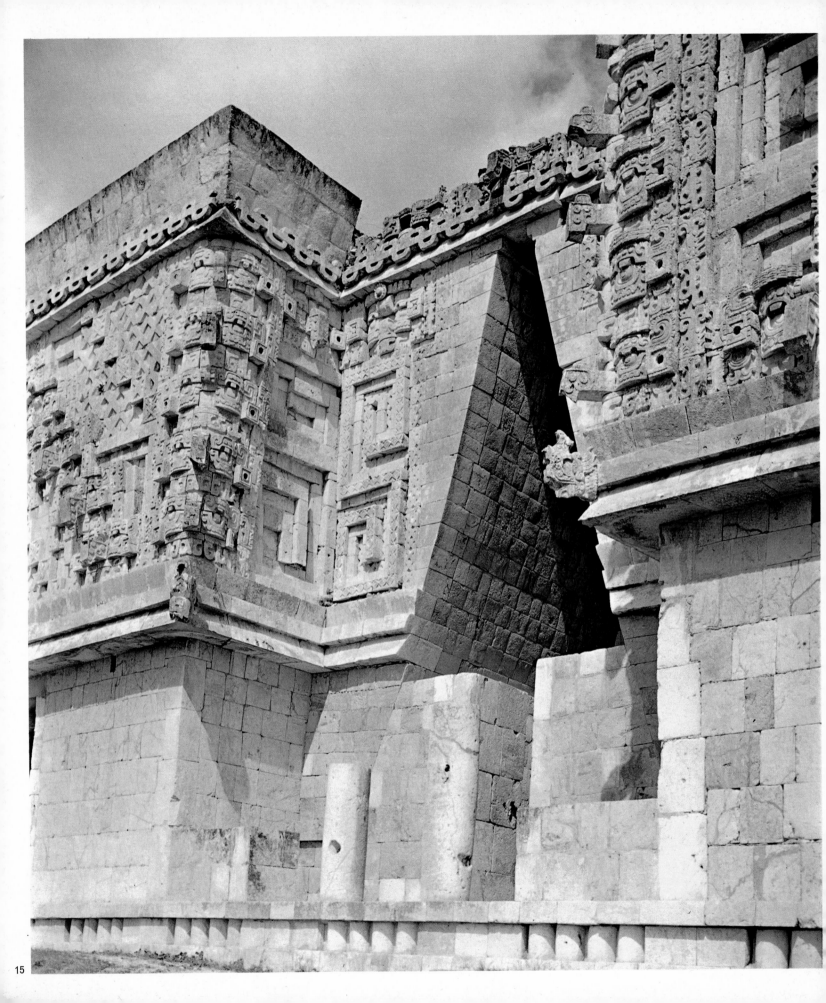

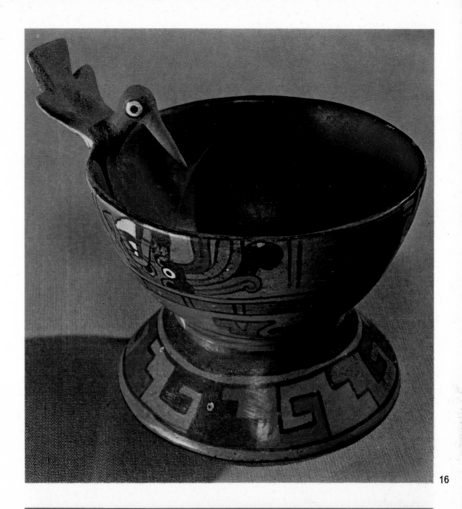

16

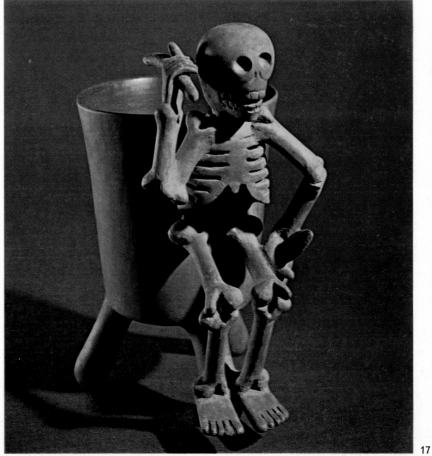

17

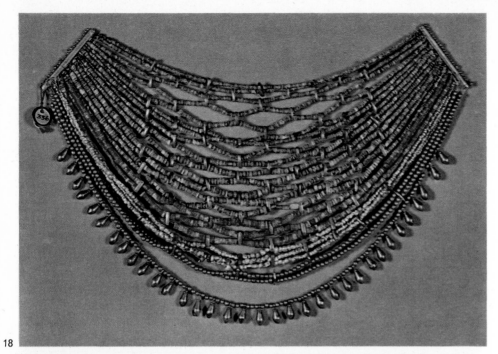

18

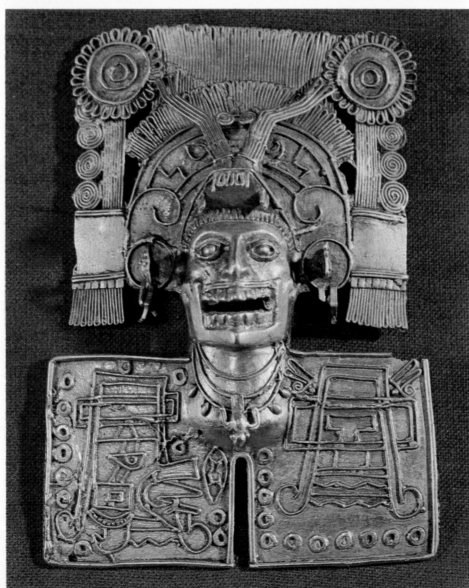

19

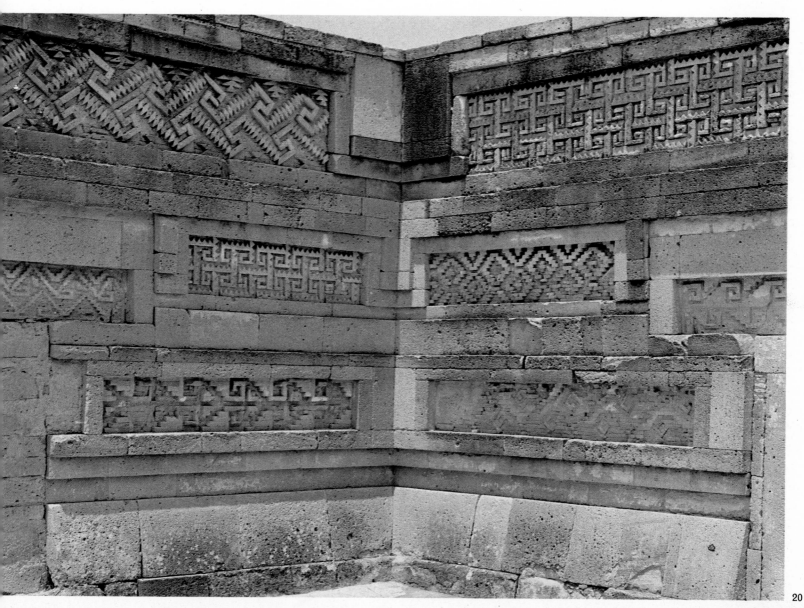

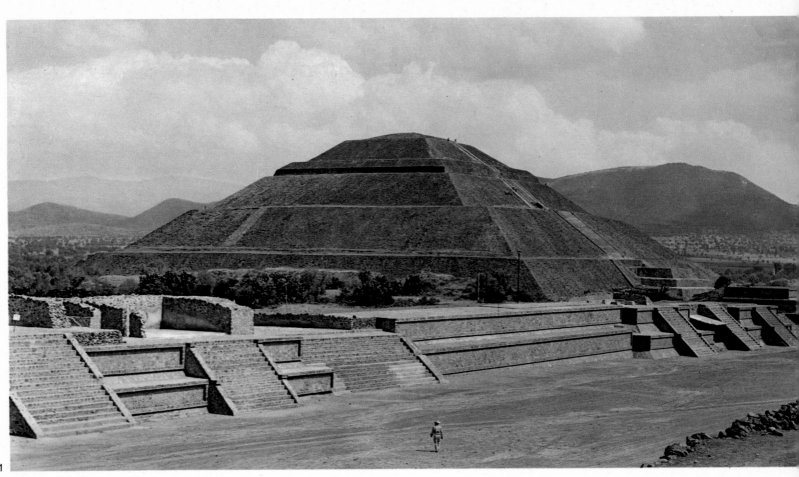

21

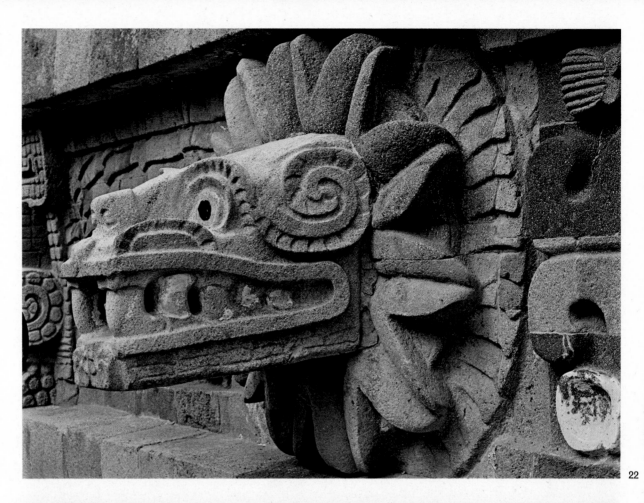

22

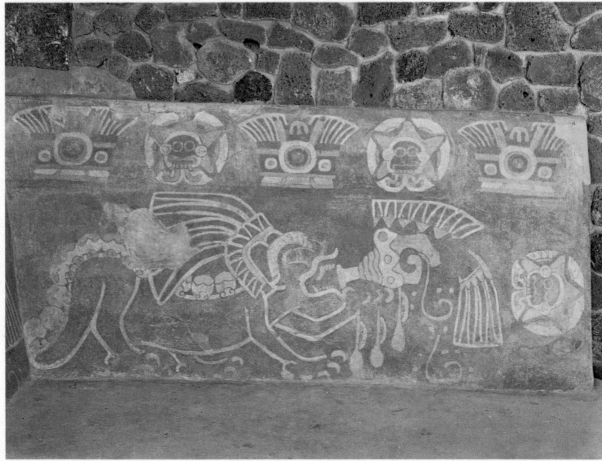

23

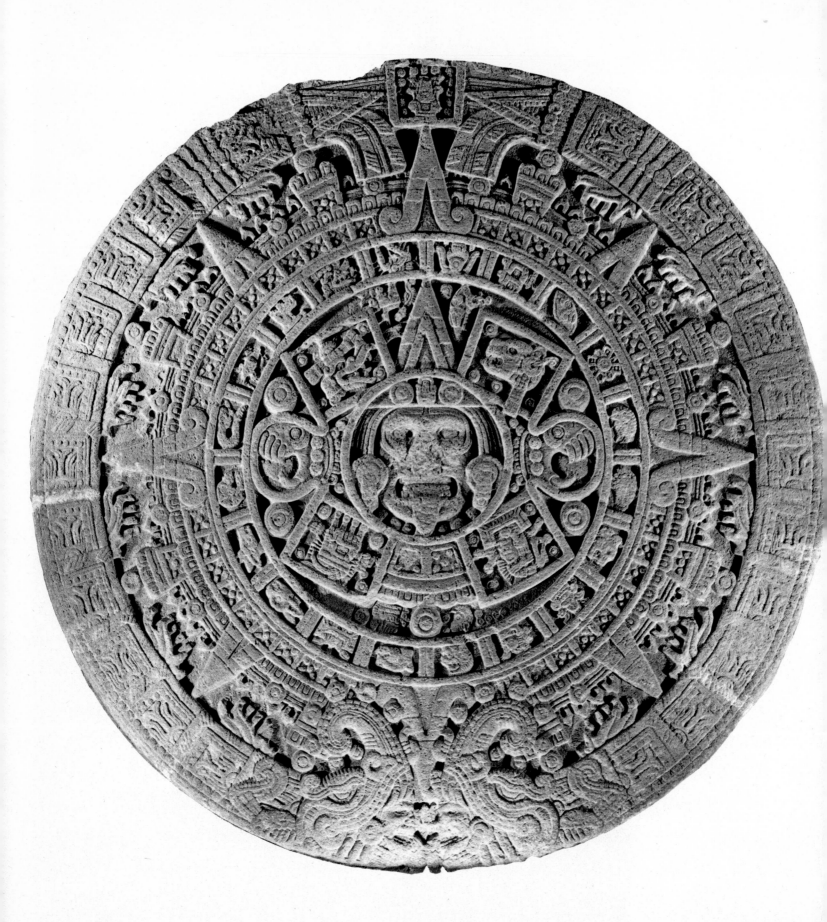

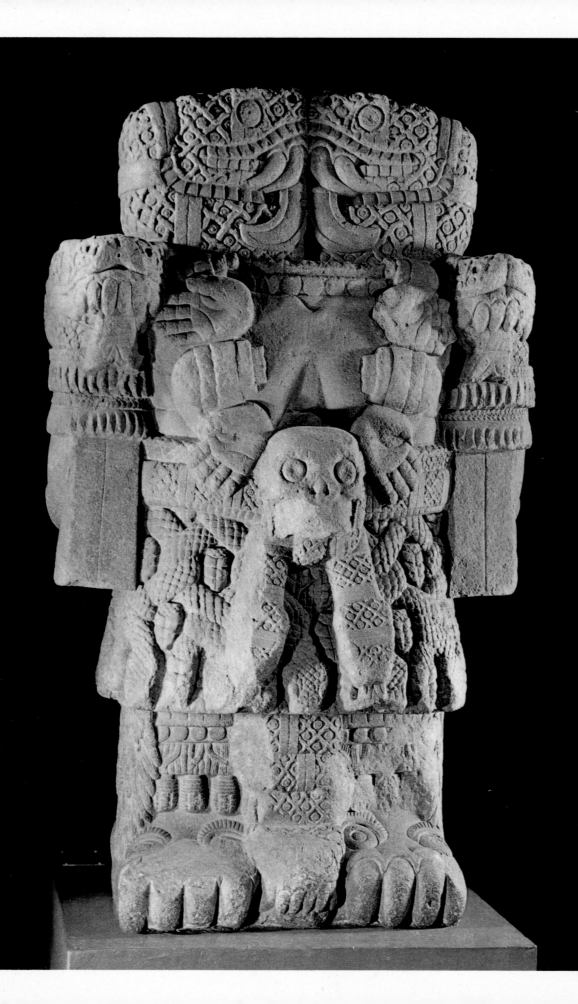

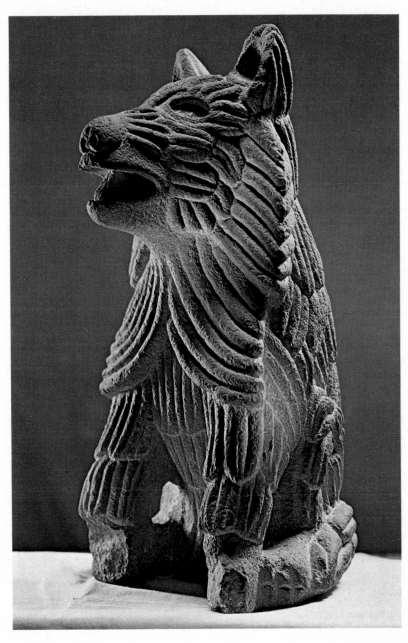

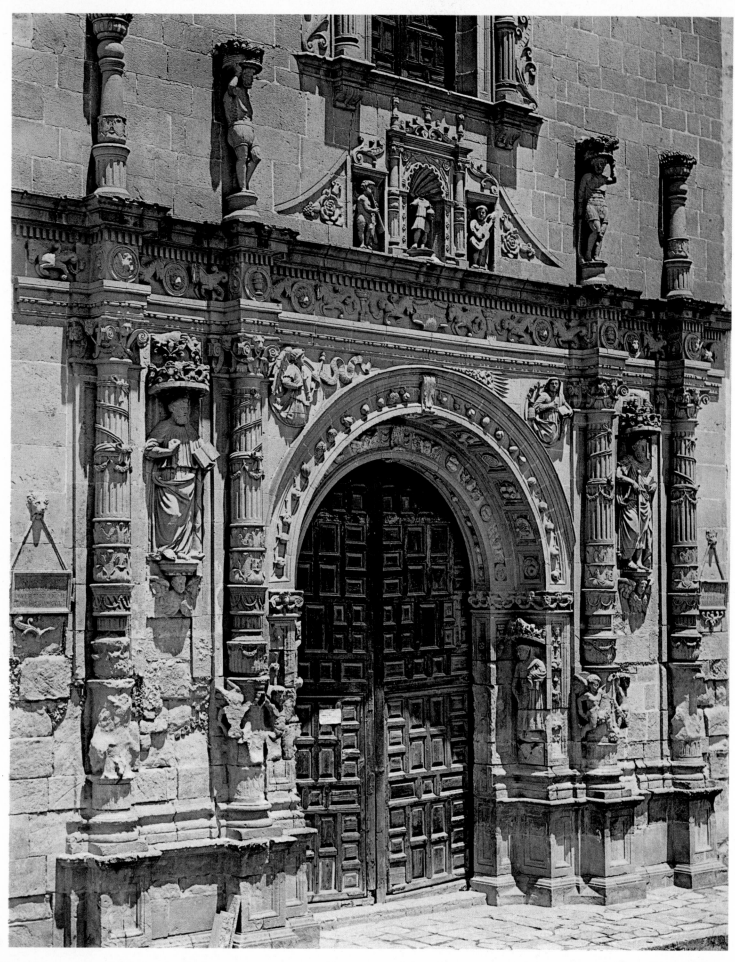

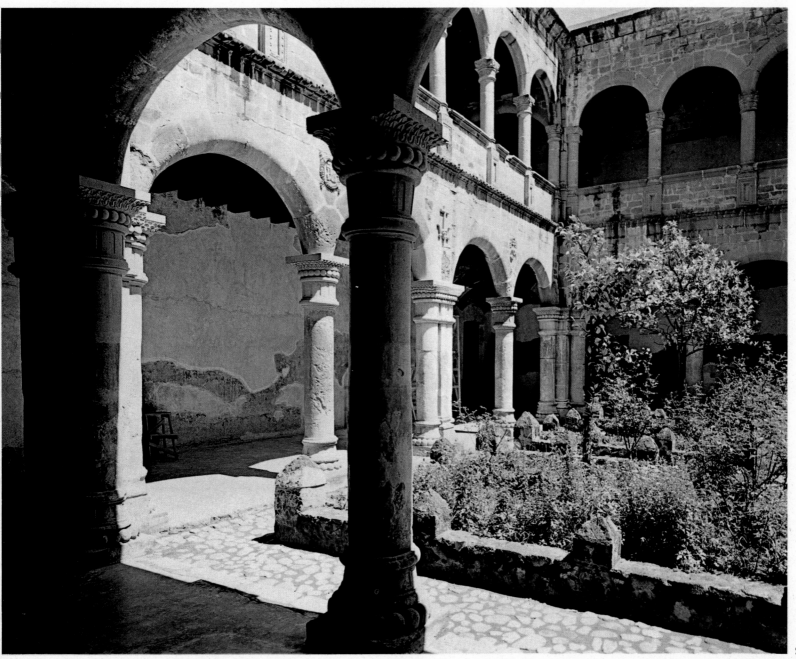

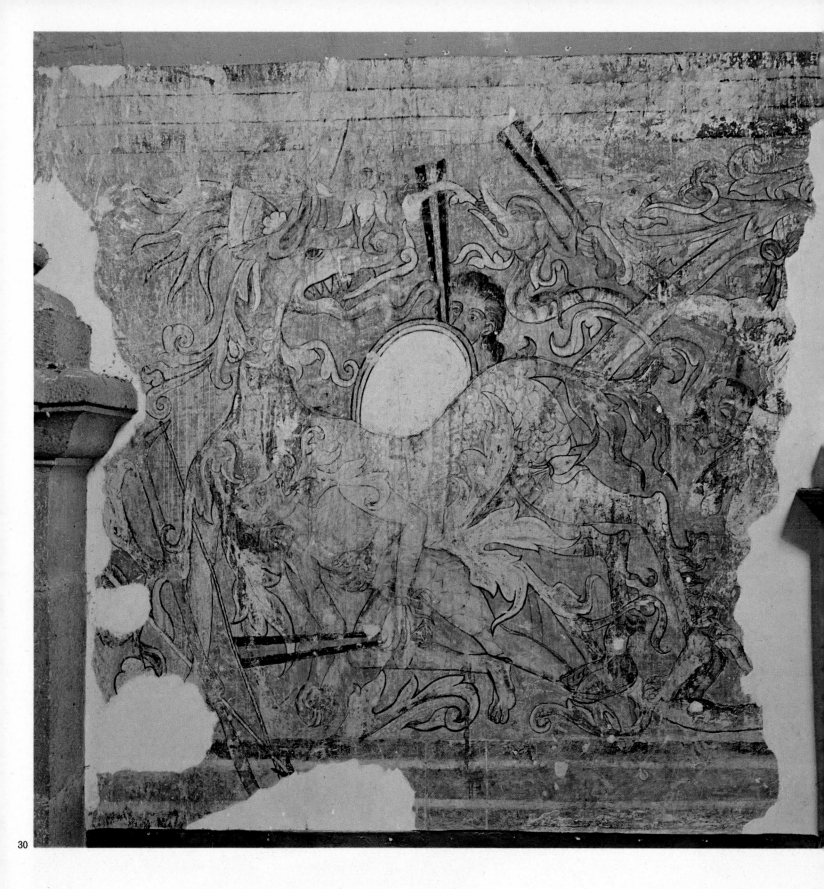

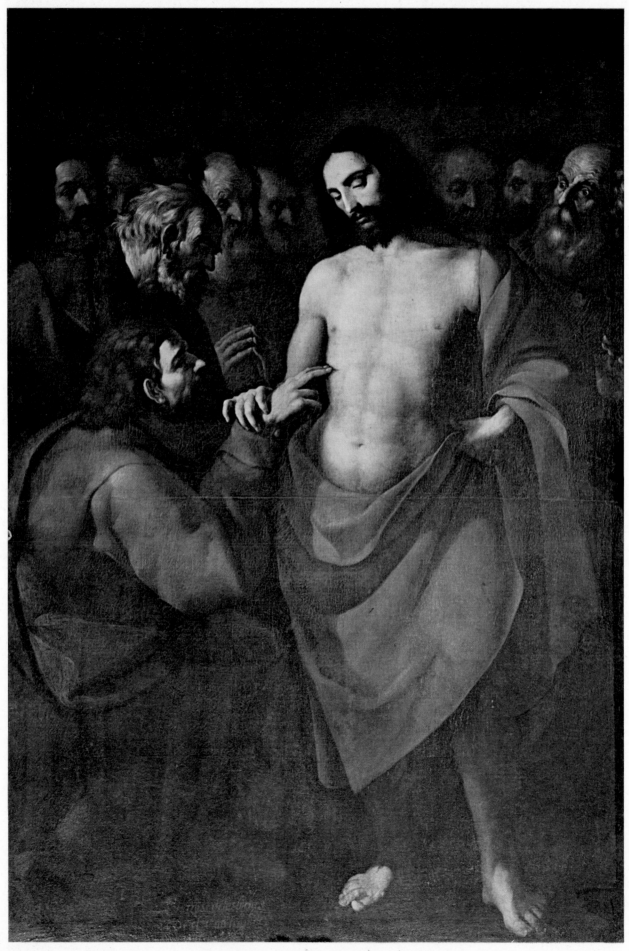

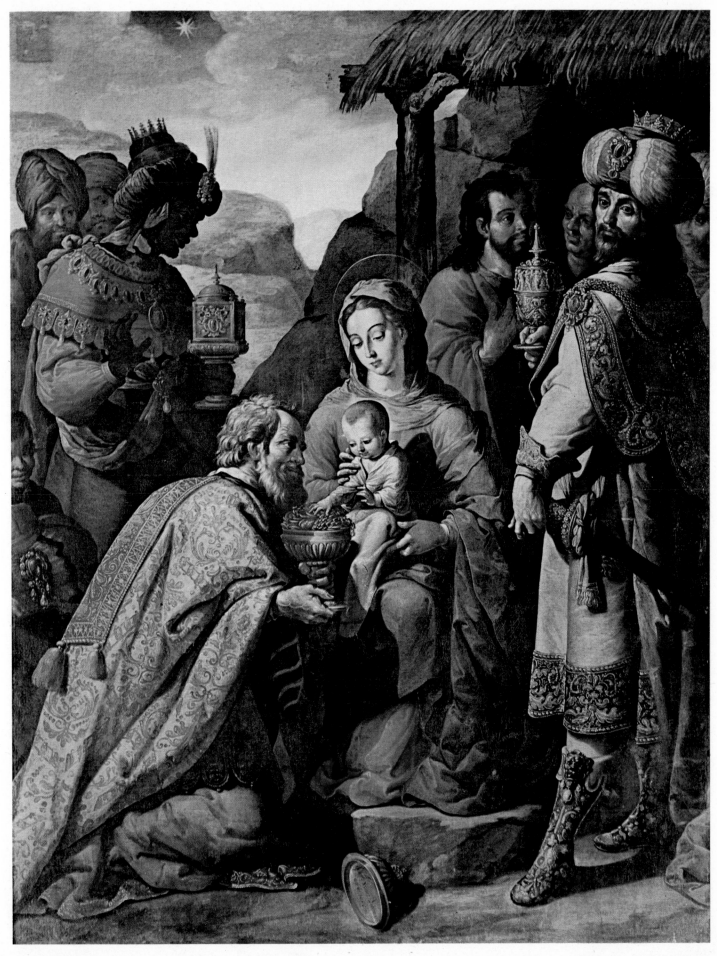

33

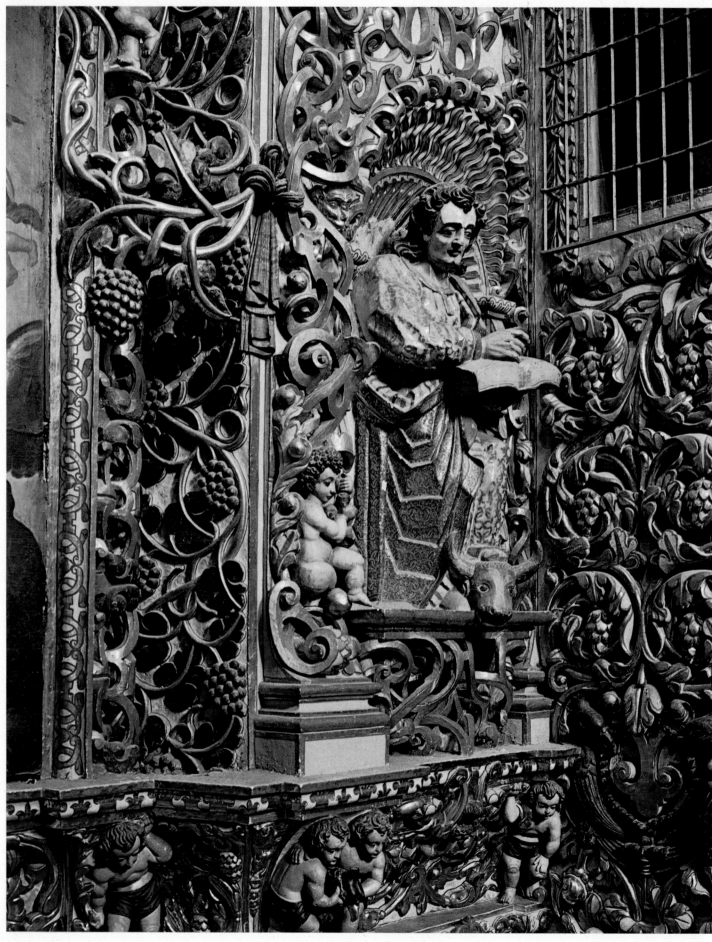

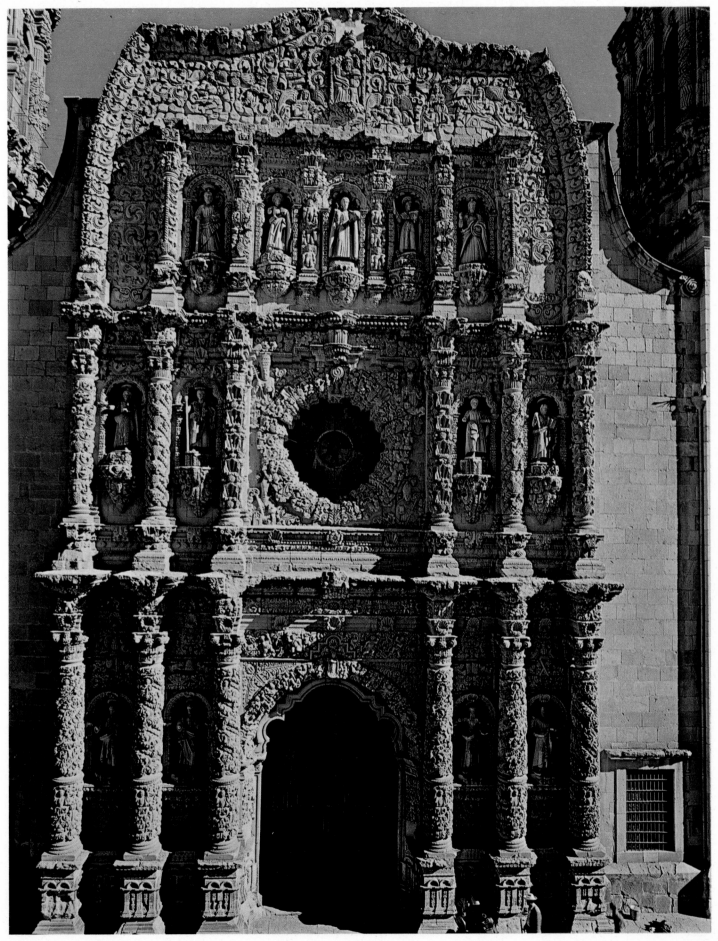

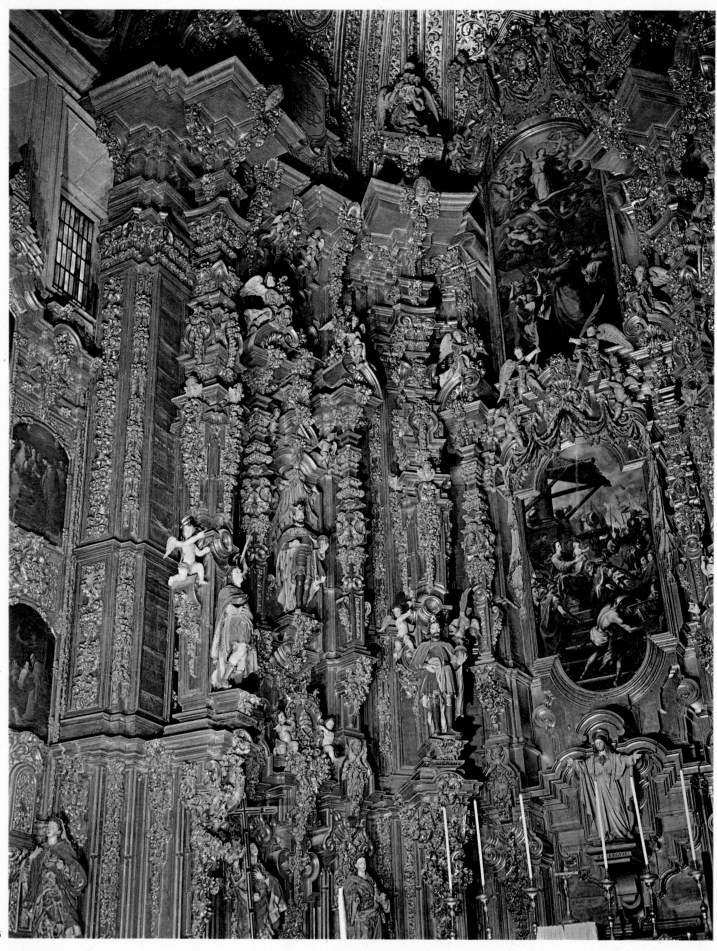

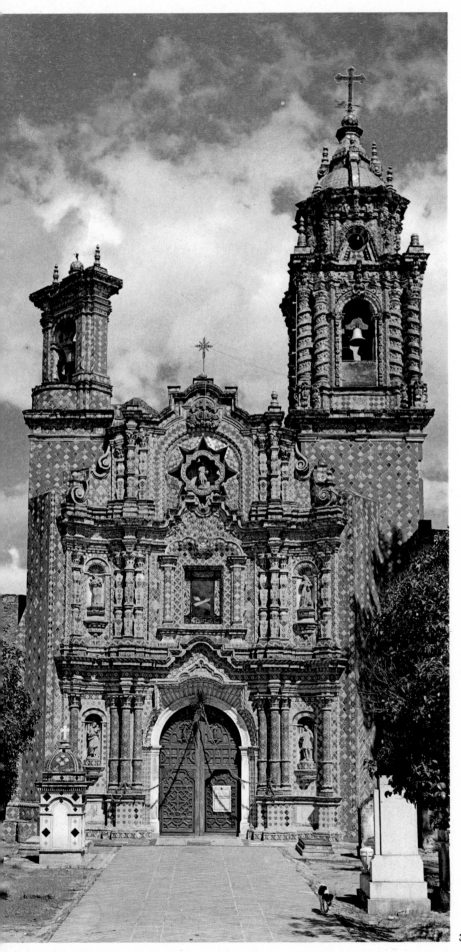

37

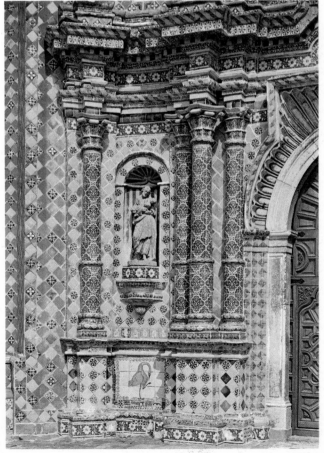

38

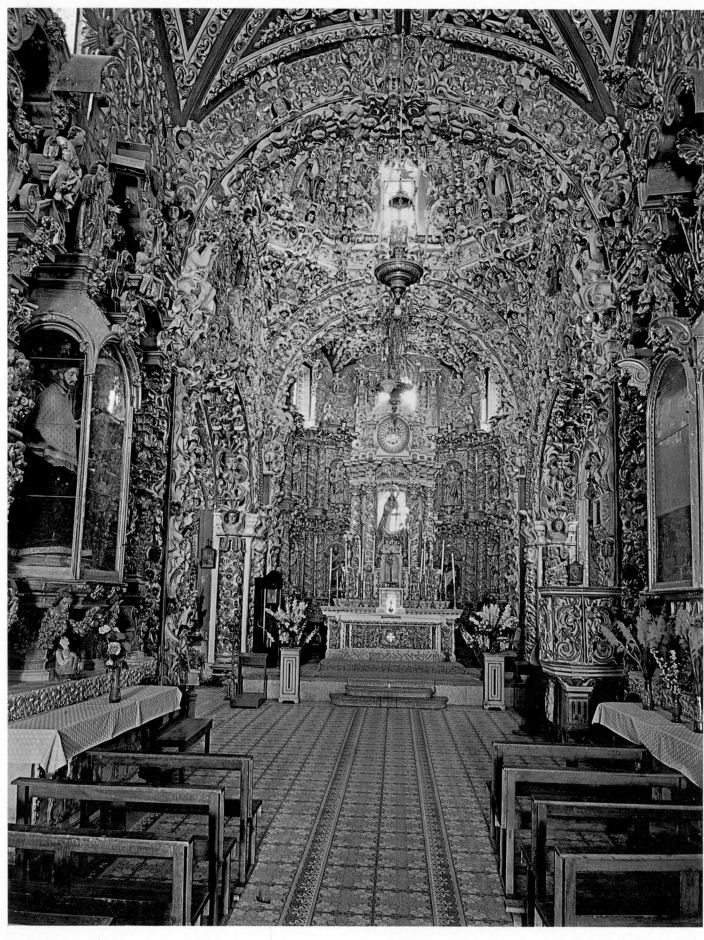

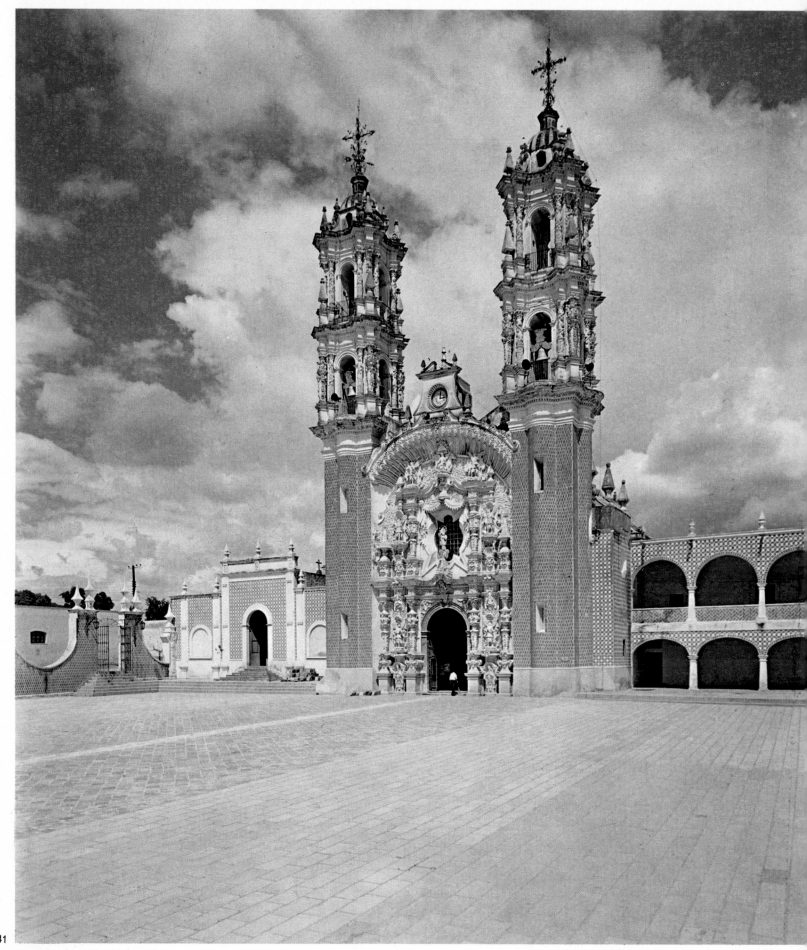

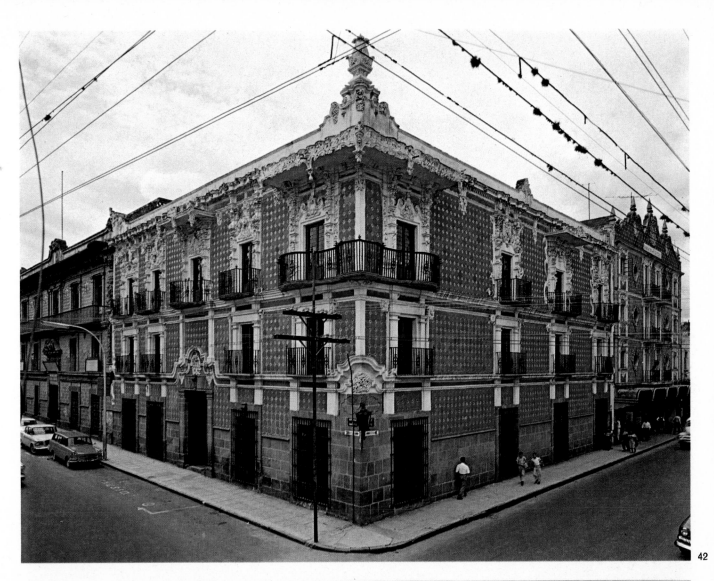

42

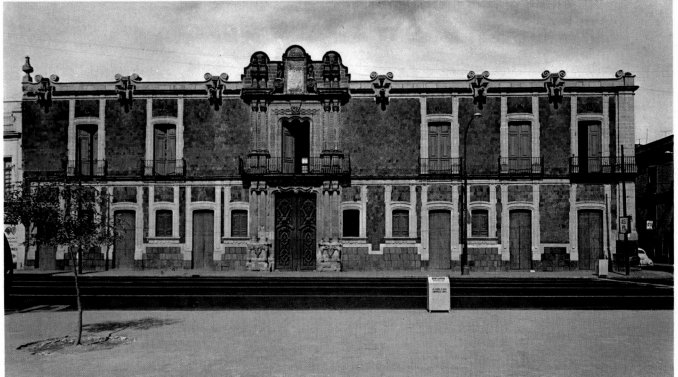

43

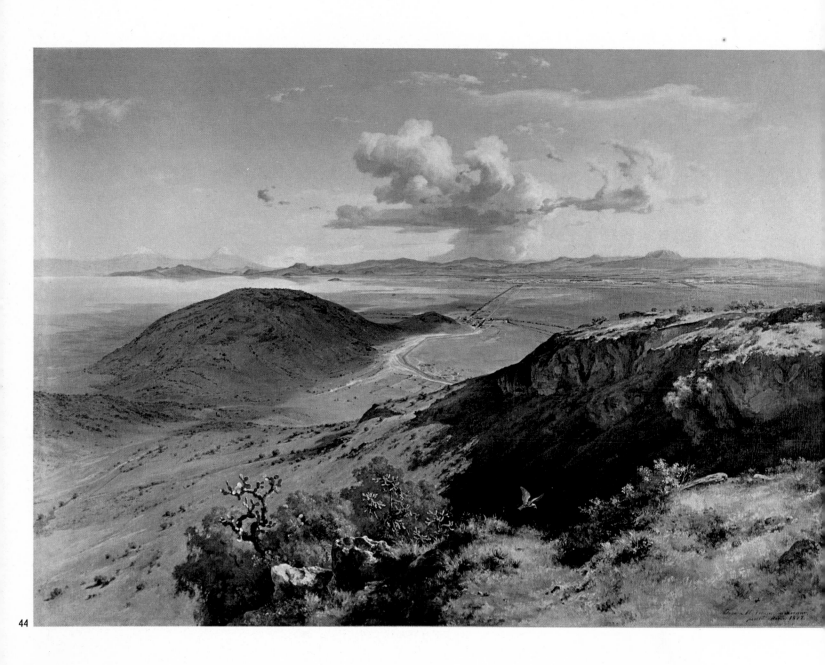

44

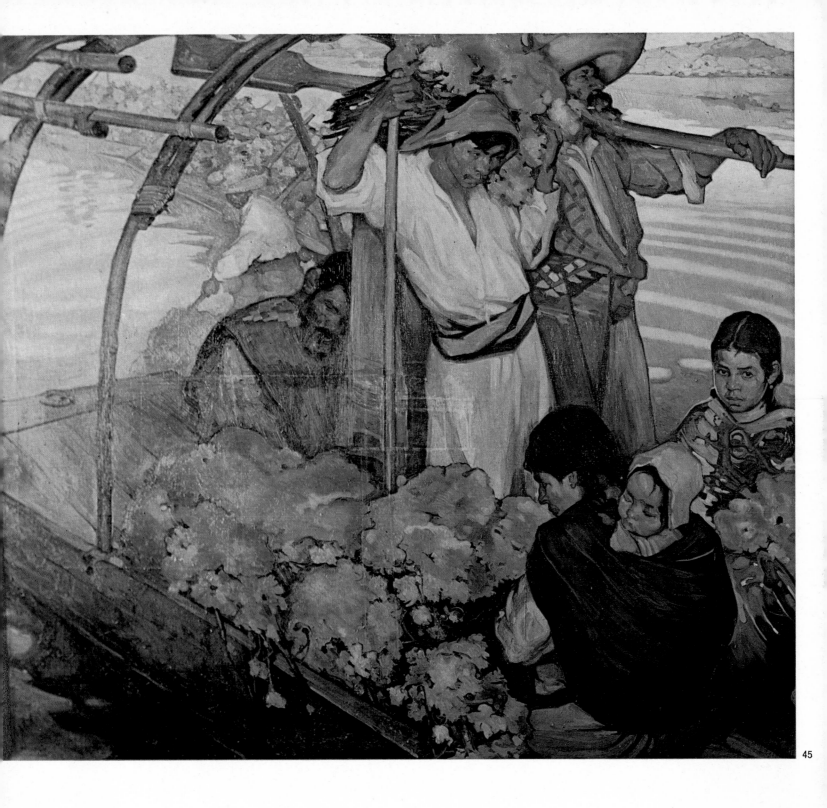

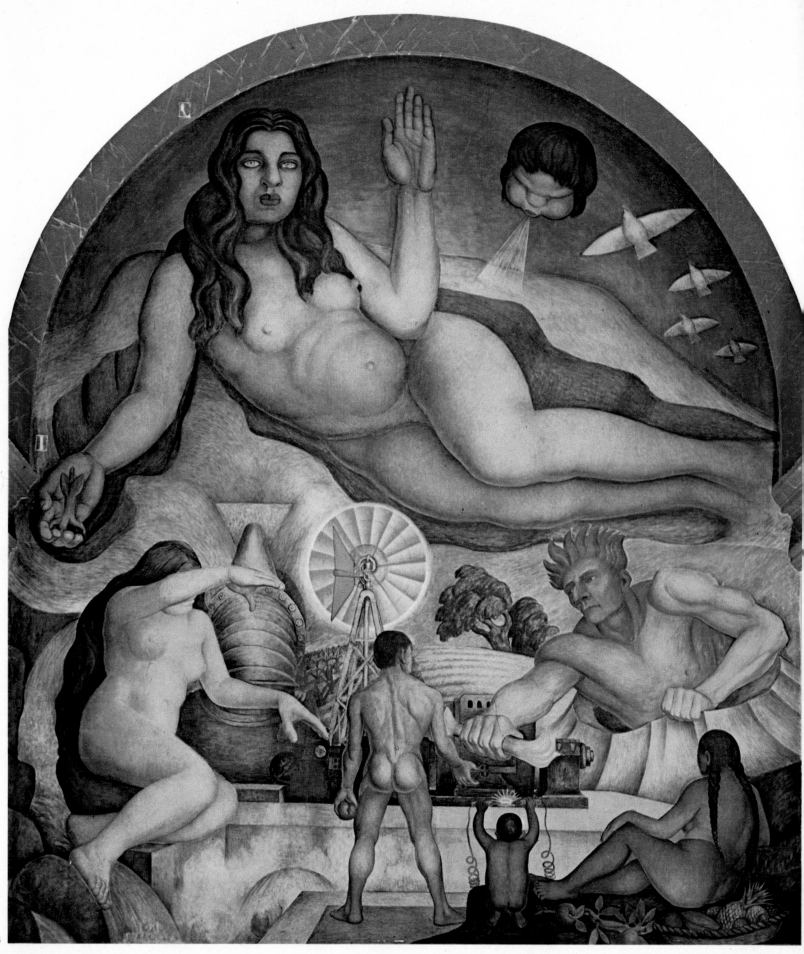

46

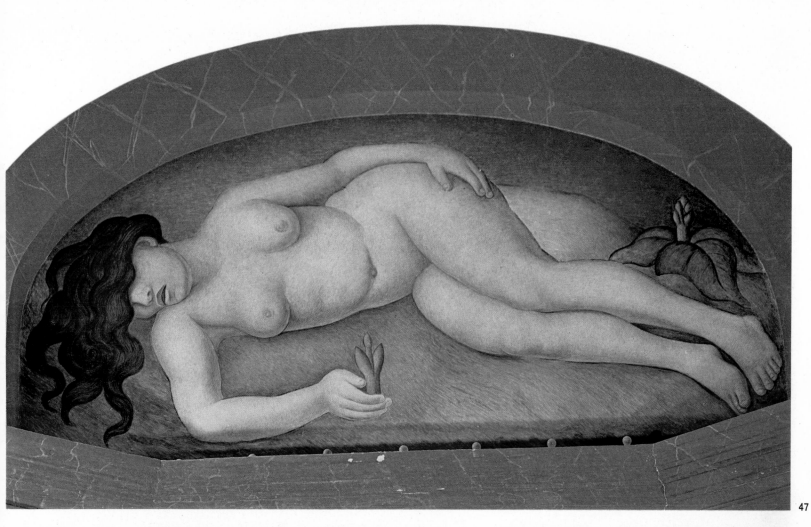

47

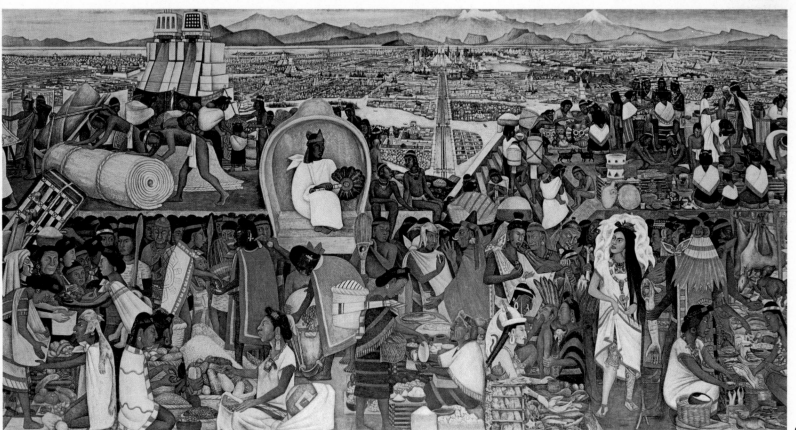

48

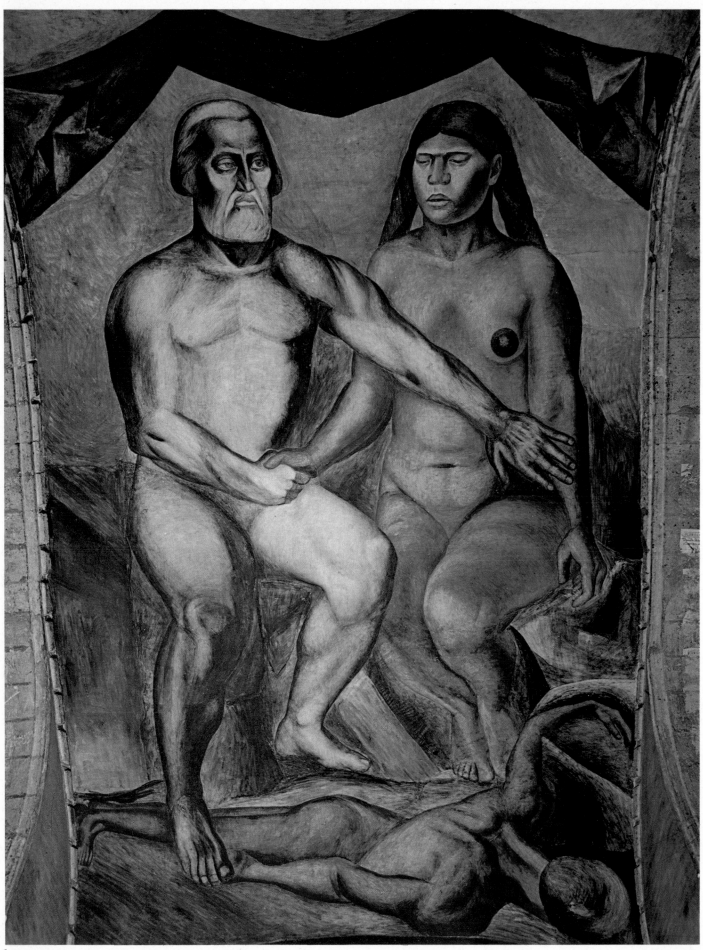

49

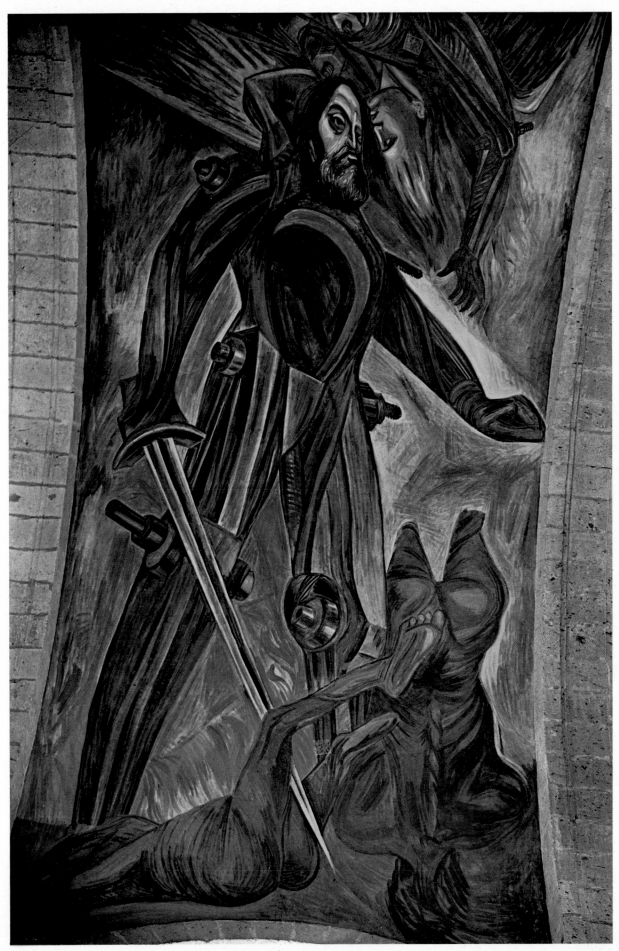

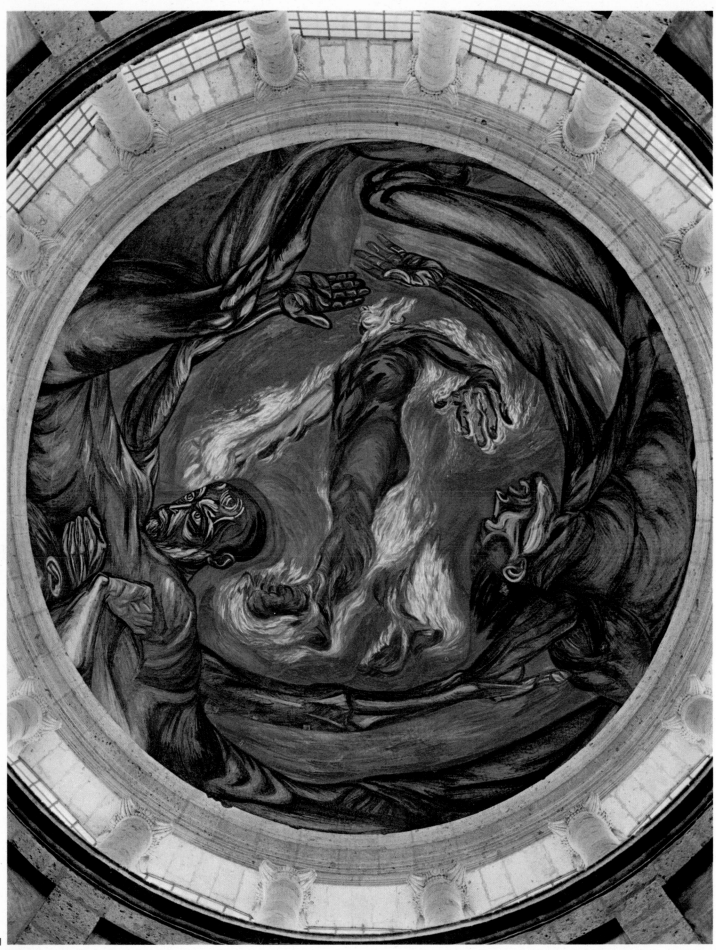

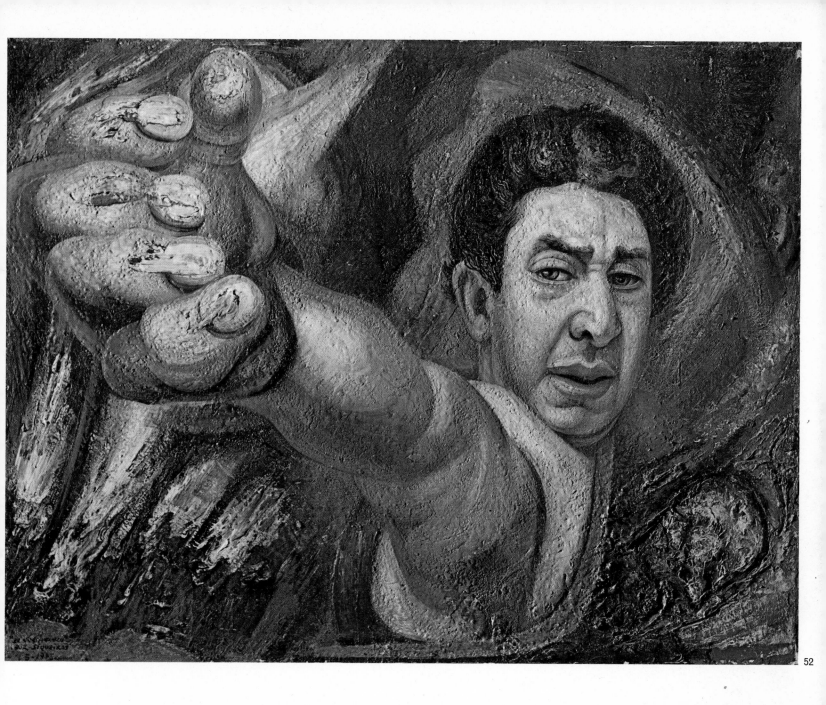

52

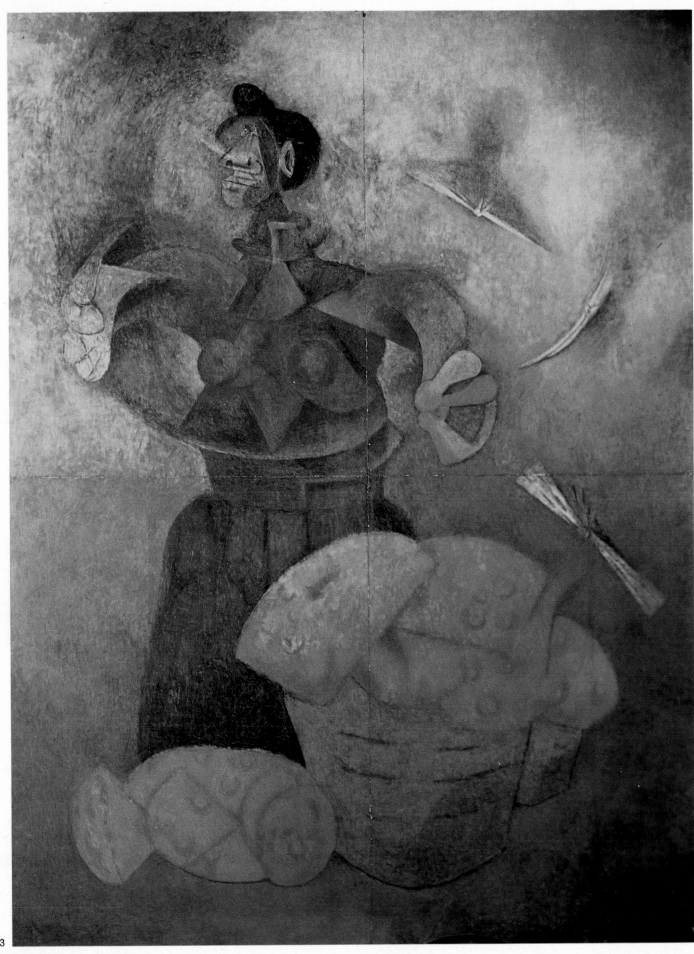

53

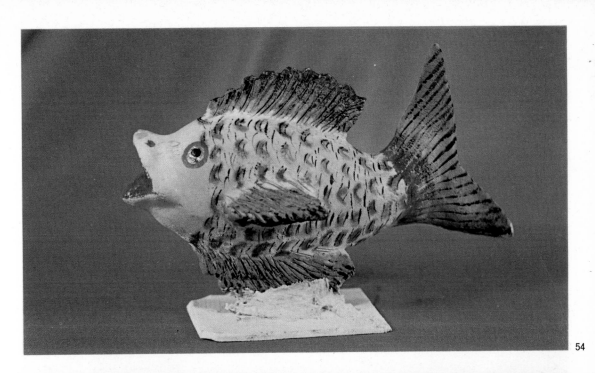

54

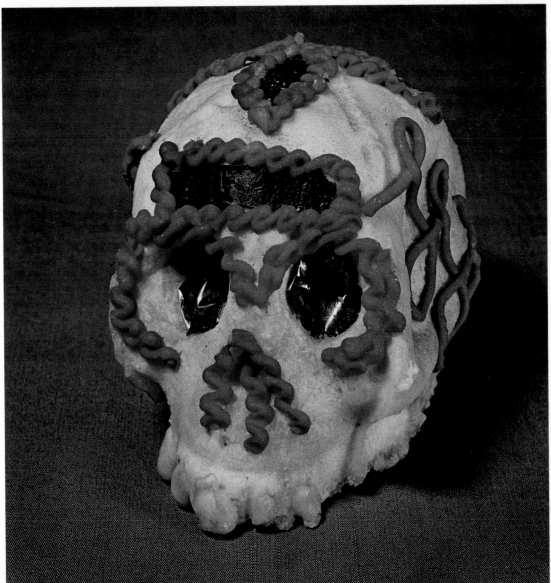

55

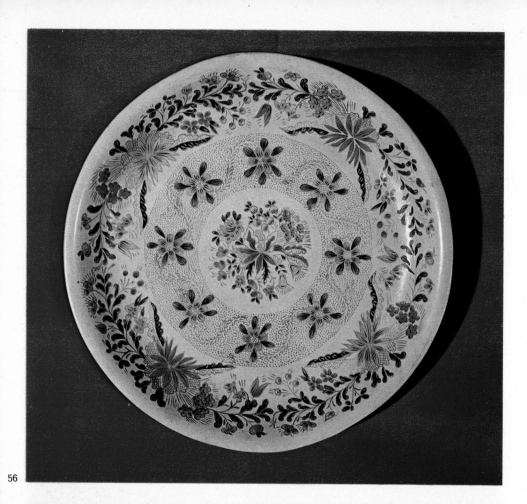

56

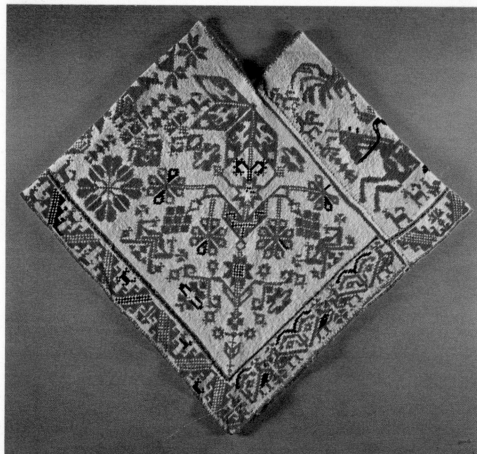

57

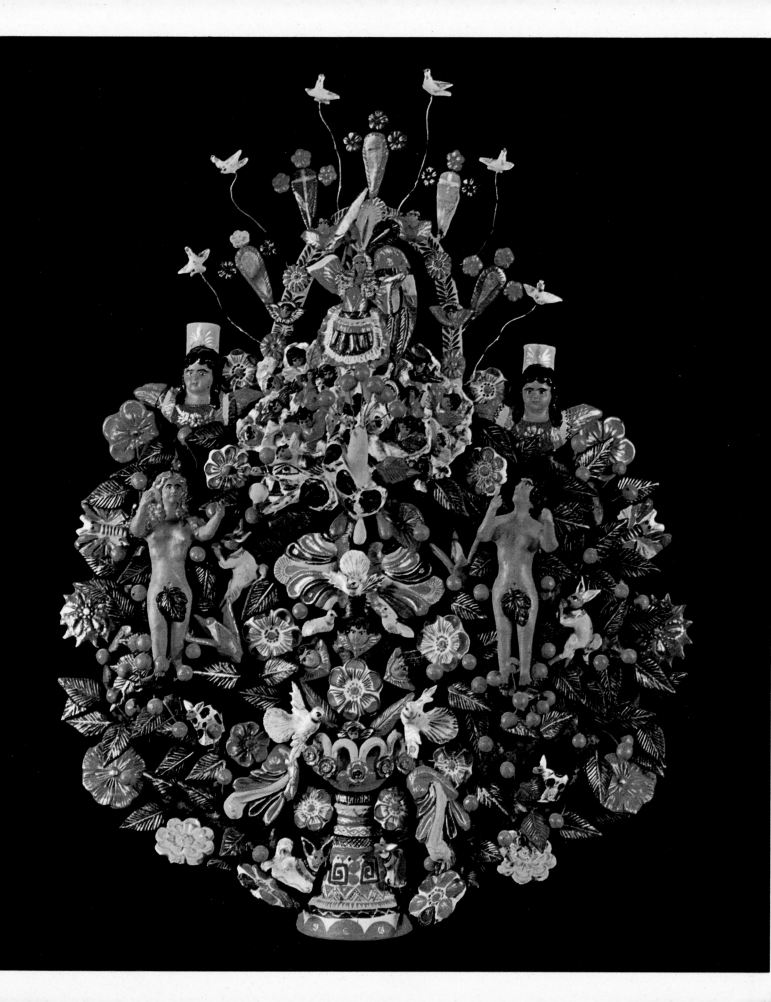

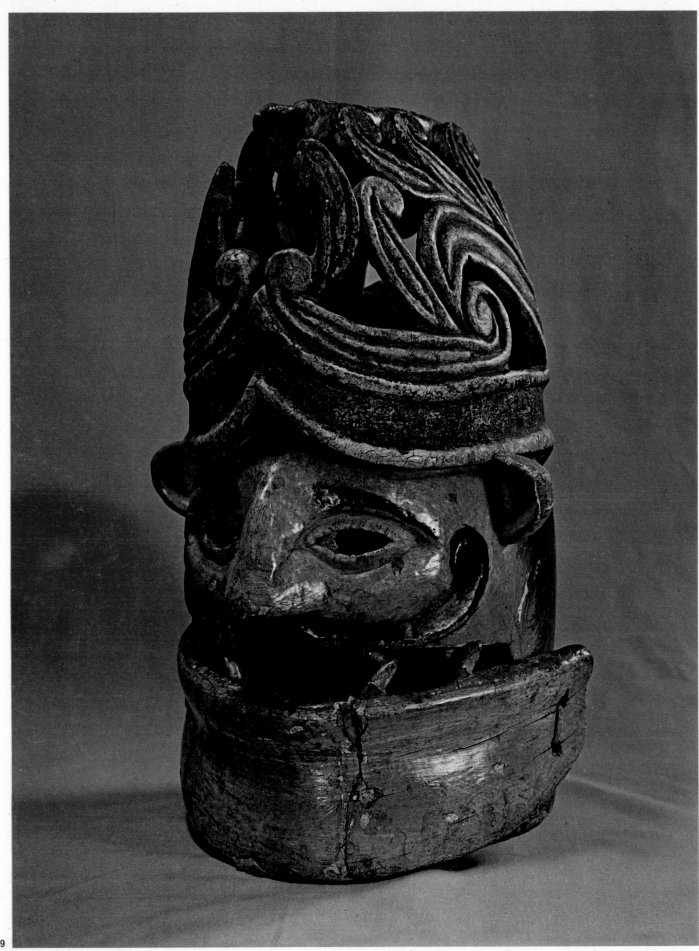